Glasgow
with a
Flourish

Glasgow
with a
Flourish

MICHAEL MEIGHAN

AMBERLEY

First published 2011

Amberley Publishing
The Hill, Stroud
Gloucestershire, GL5 4EP

www.amberleybooks.com

British Library Cataloguing in Publication Data.
A catalogue record for this book is available from the British Library.

ISBN 978 1 4456 0303 2

Typesetting and Origination by Amberley Publishing.
Printed in Great Britain.

Contents

Acknowledgements

I would like to thank the following people and organisations for their help and assistance:

Rich Hagan for the use of the images and information on the Napierian Coffee Machine – www.oldcoffeeroasters.com
Glasgow Caledonian University Institutional Archive for the photograph of Ella Glaister and of the College of Domestic Science, Glasgow.
Peter Donegan for the use of photographs and for information on his father.
Fiona Frank for Hannah Frank's 'Moon Ballet' and photograph.
Jim Friel for his encyclopaedic knowledge of Glasgow.
Helensburgh Heritage Trust for the image of John Logie Baird by Emilio Coia.
International Federation of Football History and Statistics for the photo of Robert Smyth McColl.
Janette McGinn for the photograph of Matt McGinn and permission to use 'The Effen Beekeeper'.
The Mitchell Library, Glasgow City Council, for the image of Jack House and Susan Baird; photo of Glasgow College of Science and Arts; 1-51 Jamaica Street (R. S. McColl); Sister Susies with Sir Thomas Lipton; Free Church College; 28 Saltmarket.
Jon Myer for the photo of Stuart Henry.
Wikimedia Commons for the following images – Joseph Crawhall, Aviary at Clifton, 1888; Charge of the Light Brigade and Hospital at Scutari, William Simpson; HMS *Warrior c.* 1860.
Chris73/Wikimedia Commons for image of Christopher Dresser teapot.

" Let our watchword be order, our beacon beauty."

'... in no other place have I found more love, more tolerance, more wit, more brilliance, more mediocrity, more encouragement, more frustration, more sympathy, more envy, more big men in small jobs and small men in big jobs. There may be places where women are more lovely but none where beauty and charm are found so often together. Whatever its present shortcomings as a city, Glasgow has always been hospitable.'

Tom Honeyman

Introduction

Glasgow is a great city. There is no argument about it. While researching previous books about Glasgow, I was struck by the large number of Glaswegians who have contributed to this greatness. Some of this creativity is very evident and well celebrated, such as the work of Charles Rennie Mackintosh. However, there are many more who have contributed just as much and who have possibly not received the same level of recognition. Hopefully this goes some way to correcting this.

Those I have chosen are by no means all those with a flourish. It is mostly my own personal selection, featuring names I grew up with or whom my parents and their generation talked about; people like Will Fyffe and Tommy Lorne, hugely famous in their time and all but forgotten now.

When my interest in Glasgow started me off on a quest to discover those people who have made Glasgow flourish, I suppose it was inevitable that I would look at them in terms of what made them the kind of people who are remembered as great Glaswegians.

Some of these great men have shown exceptional leadership skills. Tom Honeyman, for example, established a world-recognised Art Gallery through his quiet tenacity and persistence against bureaucratic barriers; what he called 'small men in big jobs'. Hugh Roberton founded the world-famous Orpheus Choir and Tommy Lipton founded an international tea company.

Throughout the book you will see a commitment to education. Time and time again I found that our great industrialists and inventors took advantage of new facilities such as the world's first Mechanics' Institute. Education was fostered and even in the poorer areas there were possibilities for those who wanted to pursue them.

And the Mechanics' Institute and similar clubs and societies produced 'business networking' long before it had a name. Often the same names crop up in minutes of meetings or in book references. For instance, James (Paraffin) Young was a pal of David Livingstone and funded a search for him when he was lost.

Of course, like Matt McGinn and Lex McLean, there are also those who simply gave us a laugh.

I have not ignored those, like Lord Kelvin, who may not have been born in the city but who made it their own.

Michael Meighan
July 2011

Wha's Like us?
Naebody an they're aw deid

John Blackie

Publisher, Politician and Social Reformer

Daniel Defoe, the author of *Robinson Crusoe*, visited Glasgow in 1707 and declared it 'The cleanest and beautifullest, and best built city in Britain, London excepted'. By 1807 all this had changed. While there continued to be fine new developments, building in the city was generally uncontrolled, oblivious to sanitary engineering and was outstripping the ability of the fast-growing population to be fed and watered.

The huge industrial expansion in Glasgow, aided and abetted by harsh conditions in the rural economy, was attracting migrants, mainly from Ireland, the West Highlands and from Lanarkshire and Ayrshire. In 1750, the population was 32,000, rising to 200,000 by 1830 and on its way to a half million by 1870.

This growing population was housed in poorly designed and hastily constructed buildings, which became squalid and overcrowded. This put pressure on the supply of drinking water and foodstuffs. Watercourses and wells became polluted. The city was choking in the thick smog from the vast factories, mills, workshops and foundries. Narrow streets were clogged with refuse and ordure from both man and horse.

In these circumstances disease was rampant and infant mortality high. The period also saw rises in crime, drunkenness and juvenile delinquency. It was a situation that, if left to continue, would probably see the city in economic decline and social disaster. This was a time for radical action. One of those who saw the problems and the likely outcomes was John Blackie Jnr. A publisher by trade, he went on to enable huge changes in the city, becoming a respected Lord Provost and churchman.

The firm now known as Blackie & Co. was established by John Blackie's father, John Blackie Snr, in 1809 along with friends Archibald Fullerton

Blackie's children's text, 1934

and William Somerville. This was initially based in Black Boy Close, off the Gallowgate. John Blackie Snr had been a weaver but had given that up when attracted to the bookselling business. He was employed by A. & W. D. Brownlie, canvassing and delivering books. This was called 'The Number Trade', books sold by subscription in monthly or quarterly instalments, generally to well-off clients who could afford them. Eventually the business was sold to John Blackie, Fullerton and Sommerville. They had all worked for Brownlies. They subsequently moved into publishing and in 1819 Blackies started printing their own publications.

Edward Khull, a printer, had also been associated with Brownlies and he was now taken on as a partner, setting up Khull, Blackie & Company. Bookselling continued as Fullerton, Somerville & Company. When Khull left the partnership in 1826, John Blackie Snr entered into partnership with Hutchison and Brookman of the Saltmarket. The four partners were John Blackie Snr, George Brookman, William Lang and R. Hutchison. In 1829, the firm of Andrew and J. M. Duncan was acquired. These were printers to the University of Glasgow and were based at Villafield, near to Glasgow Cathedral. The new company was established here and was to retain the title of Villafield when Blackies subsequently moved to Bishopbriggs, north of Glasgow.

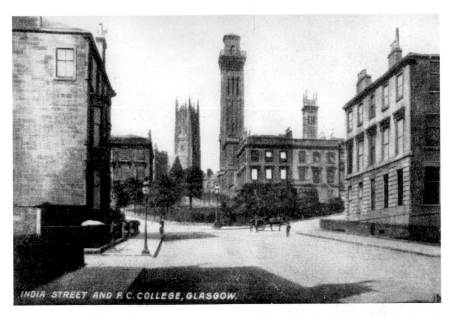

INDIA STREET AND F.C. COLLEGE, GLASGOW.

Free Church College, Glasgow

But the Blackie we are most interested in is John Blackie Jnr, who was born in Glasgow in 1805. He was one of John Blackie Snr's three sons, the others being Robert and Walter. Besides running the company, John Jnr was to show an extraordinary commitment to the wellbeing of the Glasgow citizen and was instrumental in promoting programmes of real benefit to the health of the Glaswegian.

On leaving school, John joined his father's company and on his twenty-first birthday he became a partner. It became Blackie & Son in 1831, at which time John would have been twenty-six. While the company was owned by both Johns, older and younger, it seems that John Jnr took responsibility for the publications.

These included annotated editions of the Scriptures and he had an active part in establishing the *Scottish Guardian*, the earliest religious newspaper published in Scotland. This reflects his involvement in the Free Church of Scotland, where he was an elder and where he was instrumental in establishing the Free Church's Theological College. The college had been founded by Dr Clark of Wester Moffat, who gave £20,000 on condition that there be match funding of another £20,000. John Blackie was one of the guarantors of this sum. He also gave his time and business experience, ensuring the success of the scheme.

28 Saltmarket, 1868

The Theological College was based in the iconic Trinity College building in Park Circus. The college still exists as an independent part of the University of Glasgow's School of Divinity. The original building is now private flats.

But it was as a politician that John Blackie made his largest and most long-lasting contribution to life in Glasgow. He was elected onto Glasgow Town Council in 1857, becoming Lord Provost in 1863. His major work in this time was the 1866 City Improvement Act, which was a major programme of improving life in the squalid, poorer areas of the city.

The 1866 Act gave Glasgow Town Council powers to set up a City Improvement Trust. This was to purchase slum property, demolish it and widen and re-align narrow city centre streets. The Act was also responsible for a new Cleansing Department. The areas targeted for slum clearance were mainly around Glasgow Cross. The idea was to demolish the slums of the time, widen roads and then encourage private builders

to build on the cleared areas. However, restrictions were imposed, such as limiting the buildings to four storeys. There was to be only one single apartment in each level.

However, building on the cleared land was very slow, partly caused by the collapse of the City of Glasgow Bank, as well as a recession at the time. At one time the Improvement Trust had to cease demolishing properties and found itself to be Glasgow's biggest slum landlord. It wasn't till the 1890s that building got going again and by the 1890s the Trust had build 34 tenements containing 1,200 homes. For example, Howard Street was built with sixteen single-room houses and thirty-two two-room apartments. By 1913, the Corporation that took over responsibility for housing from the Trust had built 2,199 tenement houses in the city.

The construction of single- and double-room apartments for whole families may seem very mean to us today and perhaps reflects the standards of what was being replaced.

Blackie was also involved with James Watson in doing something about the overcrowding and squalor in the common lodging houses. They intended to provide cheap, clean and healthy lodgings. The Association for the Erection of Model Lodging Houses was formed. To begin with, three buildings were provided; two for males, with 423 beds, and one for females, with 200 beds. The Association was dissolved in 1877, with the Corporation of Glasgow taking over responsibility and continuing to build more 'models'.

As a boy in Anderston I was aware of several of these 'models', one being in Pitt Street. In fact, if I came home looking scruffy my parents would refer to me as 'a Pitt Street modeller.' I remember delivering milk to at least two of them and they were not nice places. In the People's Palace in Glasgow Green there is a mock-up of one of the hutches in a model lodging house. This shows what it looked like but does not give any hint of the smell of the building or its inhabitants and the dangers contained therein. The idea that these cramped kennels were an answer to the overcrowding and squalor in Glasgow at that time seems preposterous now but it indicates how bad conditions actually were.

After all his good works, it seems that the good citizens of Glasgow didn't take too kindly to the extra taxes to pay for all the improvements at the time of Blackie's tenure as he lost his seat at the next election. However, he did receive a nice vote of thanks from the council at the end of his term.

Alexander's Public School

It appears that John's municipal work, on top of his business and Church affairs, got the better of him and he had an attack of pleurisy in 1873 from which he died, being accorded a full civic funeral. After his death his two brothers Walter and Robert succeeded him in the business, his father dying a year after John Jnr.

While many other business people were objecting to taxes raised to fund improvements and moving out of the smog and dirt to the West End or down the water, John Blackie showed his commitment to improving the lot of the ordinary Glasgow Citizen and for that he deserves recognition.

Following John Blackie's death, the company expanded continuously under Walter and Robert, producing texts to meet the expansion in education produced by the Elementary Education Acts of 1870 and 1872. This act ensured the setting up of School Boards to provide compulsory education for all children between the ages of five and thirteen. Many of the schools of the period can still be seen with their titles prominently on the walls. Here is Alexander's Public School in Duke Street.

These texts included basic English and Latin Grammars as well as children's story books. An innovative move was the production of 'reward books', which could be used as school prizes.

Perhaps promoted by Robert, who had studied under Ingres in Paris, the company took a greater interest in the covers of the books and their artistic design. Talwin Morris was commissioned to create book designs such as *The Red Letter Series*. These can be readily identified with the Glasgow Style and with Charles Rennie Mackintosh.

By 1909, Blackie & Co. had offices in London and Dublin, and had set up subsidiaries in Canada, India and Australasia. The subscription department traded under the name of Gresham Publishing, which existed from 1898 to 1948. In 1918, a scientific department was started to produce technical books.

By 1929, it was time to consider a greenfield site and a 13-acre plot was chosen in Kirkintilloch Road, Bishopbriggs, north of Glasgow. The company continued to expand and develop during the twentieth century and contributed to the Second World War effort by producing tools, shell casings and aircraft radiators. Blackie & Sons ceased publishing in 1991, with their titles being acquired by other publishers.

Walter Blackie

Publisher

John's nephew, Walter Blackie, will probably be best remembered in association with the Hill House in Helensburgh, one of Charles Rennie Mackintosh's finest works.

The Hill House is today managed by the National Trust for Scotland and is a testament to the imagination of its designer and to the boldness and trust of Walter Blackie in being a patron of Mackintosh. On visiting Hill House for the first time, I wondered why it had not been painted white. White was a colour that Mackintosh was never scared of using and it features strongly in his work, and in the work of his wife and partner, Margaret MacDonald Mackintosh.

It appears that Blackie specified a grey roughcast exterior. Perhaps this reflected his conservatism and concern for cost. He had already rejected initial designs on the basis of cost. He also brought some of his own furniture from the previous family home in Dunblane. The dining room furniture particularly seems out of place in an 'Arts and Crafts' house.

As always in carrying out research for a book, interesting facts emerge. I was intrigued by the address at which one of Blackie's first enterprises was based, Black Boy Close. This was very close to where Chrystal Bells bar is in the Gallowgate. Here there was a tavern called the Elephant and Black Boy, the site of a notorious event.

Around 1837, during a period of unrest caused by recession, there was a strike by textile workers in the East End. During this, a plot was discovered following the murder of a new textile worker. The plot was to murder new workers and masters in the textile works till striking workers' demands were met. A reward of £500 had been offered to discover the murderers and the plot was given away. There was to be a meeting of the plotters in

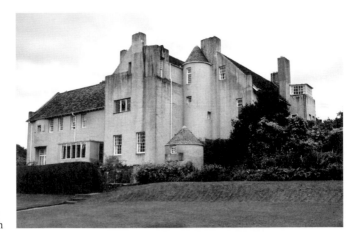

Hill House,
Helensburgh

the Black Boy Tavern but this was interrupted by the police, who found sixteen people, all on the organising committee. A trial was held in 1838 and all were sentenced to seven years' transportation. Following the capture of the committee, the Calton and Bridgeton weavers, who had been on strike for three months, returned to work.

There was a coincidence just a week after I had arrived back from holiday in Australia, where I also visited the gold mining town of Ballarat. On researching Edward Khull, I discovered that the very same Khull had emigrated to Australia following the end of his partnership with Blackie. The *Australian Dictionary of Biography* records Edward Khull, stockbroker, having been born in Glasgow, son of Edward Khull, also a printer. He had married Catherine Dennistoun, a relation of the wealthy Alexander Dennistoun and, among other things, founder of Dennistoun in Glasgow. He sailed to Australia with his wife and four children, embarking on the *John Gray* for Melbourne in 1848. He had a short-lived career as a sheep farmer before becoming government printer in 1851.

Gold had just been discovered at Ballarat and on hearing this, Khull resigned and set up as a gold broker. Using his printing and publishing skills he provided weekly reports on the gold market to the *Melbourne Argus*. When the government assumed control of gold dealings he began to deal in stocks and shares. He also founded the *Stock and Share Journal*. This was the beginning of the share market in Victoria. His business suffered from the collapse in speculative mining shares. He went into retirement and died in 1884.

Emilio Coia

Artist and Caricaturist

Emilio Coia gets a place in this book because of his eccentricity and he certainly had a flourish. He was a dapper man who would greet people with a kiss on both cheeks and signed his letters 'Con amore' although he had very little Italian – his parents' language.

The Coias, like many other Italian immigrants, ran ice-cream shops and cafés and, like many good Italian Catholics, their sons would go to St Mungo's Academy – my own school – and that is another reason for him to be in the book.

Born in 1911, Emilio went from St Mungo's to Glasgow School of Art in 1927, where it is said that he had been influenced by the artist Maurice Greiffenhagen

But the good Catholic boy blotted his jotters by eloping to London, marrying a good Protestant girl. Both sets of parents had apparently objected to the match.

Emilio touted his drawings round London papers and was successful in being taken up by the *Sunday Chronicle,* where he drew many leading personalities of the day. He also contributed to *The Sketch*, the *Daily Express* and to *The Tatler.*

He fell out with his employers after a leading columnist objected to the depiction of a chum in Emilio's first one-man show. When he refused to withdraw the picture, he got the sack and had to draw the dole instead. Being the 1930s, this was a difficult time for employment so he took a job with an engineering firm in Rochester in advertising, and then as a personnel manager. During his time he applied for the army but his work was considered too important for the war effort, so he was refused.

'The war divided me,' he recalled. 'I felt a Britisher, but my blood is

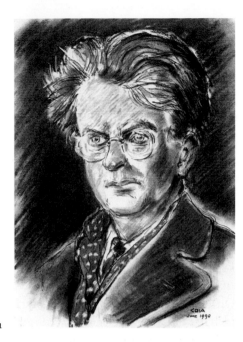

John Logie Baird by Emilio Coia

Italian. I actually tried to join the British Army at Chatham Labour Exchange but I was told I was doing too important a job at the factory.'

After the war he returned to advertising with the Dolcis Shoe Company and then with Saxone in Kilmarnock, prompted by his wife Marie's homesickness. He continued to draw in his free time and eventually turned freelance again, working first with the *Evening Times* and then with *The Scotsman* in 1953. He stayed with *The Scotsman* for fifty years. During this time he produced caricatures and art criticism for the *Scottish Field*. I remember these well. He also produced daily sketches of artists appearing at the Edinburgh Festival, with which he has become inextricably linked.

With the coming of television he became an art adviser to Scottish television in 1966 and produced sketches on TV. As an ardent fan of the early Scottish television productions, such as *This Wonderful World* and the *One O'Clock Gang*, I remember Emilio producing sketches of personalities live on TV.

He was generous with his expertise and lectured for the Scottish Arts Council. He was awarded an Honorary Doctor of Arts of the University of Strathclyde and became an honorary fellow of both the University of Glasgow and the Glasgow School of Art. He was still actively at work

for *The Scotsman* when he died in Clydebank in 1997, aged eighty-six. He took a full part in activities of the Glasgow Art Club in Bath Street, where he was president on three occasions.

Emilio worked mostly ink and pencil, although there are colour works of his in the Scottish National Portrait Gallery. These include Neil Gunn, John Laurie and Jimmy Maxton. Other sitters for his work were Augustus John, D. H. Lawrence, George Bernard Shaw and Henry Moore.

Marie Coia, also an artist, was former president of the Scottish Society of Women Artists. She died in 1978.

Glen Daly 'Mr Glasgow'
Entertainer

Glen Daly has to be in my list of Glaswegians with a flourish. He was a well-respected entertainer with a career spanning several generations of fans.

I only saw Glen once, as far as I can remember, but it must have been memorable as I can remember what he sung. He was the 'star turn' at St Patrick's Anderston School concert in the mid-1960s and I particularly remember him singing 'The Gypsy Rover'.

Glen was born in 1930. On leaving St Mary's School in the Calton, Glen, born Bartholomew Francis McCann McGovern Dick worked in the Clyde shipyards, just like his fellow music hall and Pavilion chum, Lex Mclean. Glen started his career in Glasgow's Metropole, but it was as a 'feed' to Lex Mclean at the Pavilion that his career began to take off. At the Pavilion his contemporaries were the up-and-coming artists Andy Stewart and the Alexander Brothers, Tom and Jack.

Besides making TV appearances on the *White Heather Club*, he toured extensively abroad, including Australia, Canada and the USA. In Blackpool he entertained Glasgow 'Fair Fortnight' holidaymakers, sharing the stage with Ken Dodd, The Bachelors and The Nolans.

Glen was extremely comfortable with club singing and was a regular at Glasgow's Ashfield Club. *The Very Best of Glen Daly (Live at the Ashfield Club)* was a huge hit and he went on to make other successful albums, including *Legends of Scotland*, *Glasgow Night Out* and *Glen Daly 'Mr Glasgow'*.

If Lex McLean was a dedicated Rangers supporter then Glen Daly was Glasgow's exact opposite. How more Celtic can you get than to have a football fan club named after you, as they did with The Glen Daly

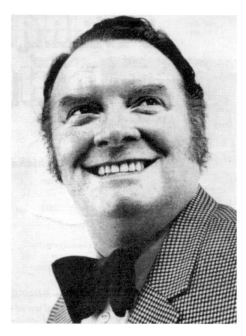

Left: Glen Daly

Below: The Glasgow Pavilion

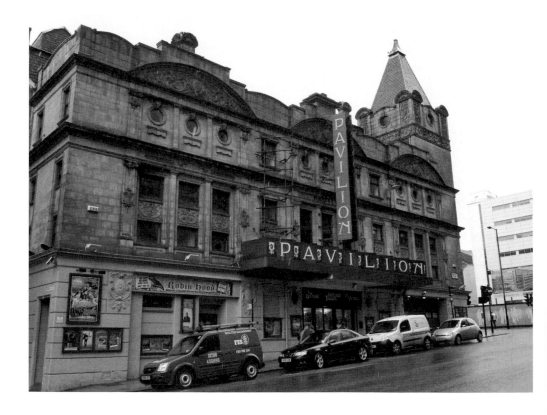

Rothesay Celtic Supporters' Club? Some people even believe, incorrectly, that Glen Daly wrote 'the Celtic Song', the anthem that he is most closely associated with and which he took into the UK charts in 1961. This and his huge Irish Catholic following have given him the name 'Mr Celtic'.

He was also made honorary vice president of the Celtic Supporters' Association in recognition of his services.

Glen became ill in the early 1980s and retired to Bute, where he passed away peacefully at his home. He is buried in Rothesay's Barone cemetery.

For interest, 'the Celtic Song' was actually written by Mick (Garngad) McLaughlin and the rights sold to Glen Daly for ten pounds. Mick Garngad also wrote many other Celtic anthems as well as being a local poet. The Celtic Song was famously sung in an episode of the cult American series 'Lost'.

Lonnie Donegan

Singer/Songwriter

Anthony James Donegan was born in Bridgeton, Glasgow, in 1931. While he didn't live there long, his connection has never been forgotten and his music has always been popular.

Lonnie's father had at one time been a musician with the Scottish Orchestra. In 1933, the family moved to East Ham in London, his father becoming a musician on cruise liners before joining the Merchant Navy.

I like to think of my father, who lived in Bridgeton in those days, bumping into the Donegans as young Anthony James was pushed along in his Churchill Pram. You never know, they may also have met a young Glen Daly being pushed in his pram, as he was also born in Bridgeton, in 1930.

Following his move to Altringham, Anthony became an office boy for a stockbroker in London but was called up in 1949, serving his time in the Royal Army Medical Corps.

His son Pete Donegan told me, 'He actually got his influence from his time in the army when he was posted to Vienna, and used to sneak off to the United States Army barracks and listen to their 'trad' jazz and blues music from the American radio stations piped through for the US troops.'

After being demobbed, he worked for Millets Army Surplus Store. By this time he had the music bug. Lonnie bought his first guitar and started playing round the London jazz clubs. His first big break was when he joined the great Chris Barber[1], along with Monty Sunshine and

[1] For information, British jazz trombonist Chris Barber celebrated his sixty-second year as a bandleader in 2011. It has been one of Europe's most successful jazz bands with more than 10,000 concerts. Chris says that he was inspired by the King Creole Jazz Band and formed the Chris Barber New Orleans Band in 1949.

Ken Colyer. When Colyer left the line-up, Chris Barber's Jazz Band was formed. During this time, it is said that, because of a compere's mix up, he adopted the name of the American blues singer Lonnie Johnson[2].

It was with the band that 'Rock Island Line' was recorded in 1954. 'Rock Island Line' changed the face of music and Lonnie took his position as 'The King of Skiffle'. This opened to him appearances on the Perry Como Show in America, where he played on the stage and in clubs alongside those other legends Chuck Berry and Bill Haley and The Comets.

Lonnie's influences have been enormous. Paul McCartney and John Lennon, prior to their Beatles days, were in a skiffle group called The Quarrymen. McCartney explained that it was Lonnie who started the craze for guitars, which they followed, doing some of his numbers.

While skiffle faded out with the coming of the Merseysound he continued to work in cabaret, mostly in the USA and Great Britain. He made occasional stage appearances, including in *Mr Cinders*, a West End musical in 1984.

Lonnie's contribution of more than twenty UK Top 30 hits has been recognised in the Guinness Book of Records, which acknowledges that he was the most influential recording artist before the Beatles. Lonnie was awarded the MBE in 2000. He also received the British Association of Songwriters, Composers and Authors' Ivor Novello Award for his 'Outstanding contribution to British music'. He died in 2002, still working and midway through a tour. At his funeral, one of his songs was sung in tribute: 'Over in Gloryland'. *The Guardian*'s obituary said 'he was first British pop superstar and the founding father of British pop music'.

Lonnie will be remembered fondly for his contributions to music and to musicians. We will always remember 'Putting on the Style' and 'Rock Island Line'.

For me, one of Lonnie's best song ever was 'Bewildered'. This is a rarely played song. However, The Notting Hillbillies, of which Mark Knopfler[3] is a member, reprised it and did an excellent job. Mark cites Lonnie as

[2] **Alonzo "Lonnie" Johnson** was an American Blues and jazz singer who was a pioneer of jazz guitar. He played with Louis Armstrong and his Hot Five as well as Duke Armstrong. It was when he toured England in 1952 that Tony Donegan, on the same bill, paid tribute to Johnson by changing his name to Lonnie.

[3] **Mark Knopfler** is also a Glaswegian, son of an English mother and Hungarian Jewish father. When he was seven the family moved to his mother's home town of Blyth in Northumberland.

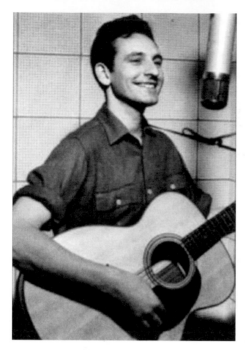

Anthony James (Lonnie) Donegan

being one of his major influences and released 'Donovan's Gone' on his 2000 album, *Shangri-La*.

Lonnie Donegan's music lives on in his huge repertoire, and also in the Lonnie Donegan Band, formed by him and with whom he toured for the last thirty years. The band members have now been joined by Lonnie's son, Peter, who told me, 'We do keep my dad's music alive and do a fair few of my dad's songs in our set. But a good chunk is actually our own material too.'

Christopher Dresser

Pioneer of Industrial Design

I first came across Christopher Dresser in the 1977 reprint of Arnold Fleming's wonderful and comprehensive 1938 *Scottish and Jacobite Glass*. In the chapter on James Couper & Sons, he explains that ' 'Clutha' Glass in brilliant lustrous effects designed by Dr Christopher Dresser had a gratifying vogue; the gem-like flashed forms were greatly admired, especially in tints of aventurine, sapphire and amethyst'.

What surprised me about this was that such futuristic organic and colourful pieces were being produced in Glasgow at the end of the nineteenth century. Secondly, that there was design behind their manufacture, the designer being Christopher Dresser.

It was three years later that I discovered the true extent of Christopher Dresser's work, and that he had been born in Glasgow. At an exciting and adventurous exhibition held at the Dorman Museum in Middlesbrough in 1980 and the Camden Arts Centre in 1979, I found out that while his work had not been much known about, he was considered to be the founder of industrial design. Much of his output was based on his love of botany.

Christopher Dresser was born in Glasgow in 1834, to Christopher Dresser, an excise officer, and Mary (Nettleton). Both his brothers were also excise officers. We don't seem to know what attracted him to design except that, although young, he may have attended the new Glasgow School of Design[4],

[4] The Glasgow Government School of Design was the name of the Glasgow School of Art before it changed in 1853. It was originally based at 12 Ingram Street before moving to the McLellan Galleries in 1869. Here the art school stayed until 1899, when the existing building opened.

The McLellan Galleries were the gift of Archibald McLellan, who had been a coachbuilder, councillor and patron of the arts. I have been at many exhibitions in the McLellan Galleries. They have served the city well as an exhibition space and when the Art Gallery has been closed.

which opened in 1845. Neither do we know how he managed to become a student at the School of Design at Somerset House in London, where he started in 1847. He was thirteen at the time but it wasn't so strange, as boys also went into the Navy at that age.

He clearly did extremely well in the field, winning prizes and scholarships for interior design.

An 1857 paper was delivered to the Royal Institution: 'On the relation of science to ornamental art'. The following year he read a paper to the Linnean Society on 'Contributions to Organographic Botany'. These papers show that he had become interested not just in industrial design, but also in relating design to organic growth. He studied botany and was eventually to become a professor of ornamental art and botany in the Crystal Palace, Sydenham.

Up to his death in 1904, Christopher Dresser appears to have gained a huge reputation for his skill and experience in ornamental art and is credited with popularising Japanese Minimalism in the West.

His credits include cast iron, the letterboxes still being seen today, wallpaper, silver, pottery and ceramics. His silverware for Huskin & Heath, Elkington & Co., and Beham & Froud is immensely collectible and the silverware particularly sells for thousands of pounds. He also designed linoleum for two Kirkcaldy factories, so you may have walked upon his work at some time.

That exhibition in Middlesbrough opened my eyes to the skill, insight and forward thinking of Christopher Dresser, who turns out to have been in the forefront of industrial design as a consultant. His designs for metalwork are futuristic and engaging in their unexpected squareness and angles.

I particularly like his botanic studies, and specifically where applied to ceramics. Dresser was designing tiles for the Minton Company, for Linthorpe Pottery, and this stoppered decanter and underplate was for Watcombe Terracotta Company in around 1870.

My greatest fascination in all of this was the fact that he had not abandoned Glasgow, but had designed Clutha glass for James Couper & Sons. James Couper supplied glass and china from the Candleriggs. It was in 1850 that he started manufacturing, acquiring land where Couper Place and Couper Street are now. I know that area well as I went to school there and I remember passing bottle kilns behind Kennedy Street as I walked through Townhead. My memories are that the buildings were used as a garage in the late 1960s, but as things were

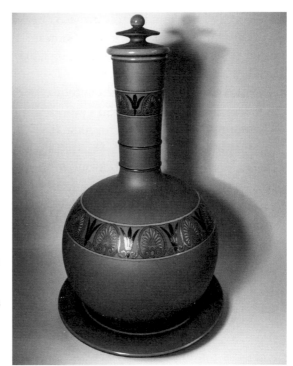

Right: Watcombe Terracotta, *c.* 1870

Below: Christopher Dresser's iconic teapot made by Brian Asquith, Derbyshire, England, for Alessi S.p.A. Crusinallo, Italy

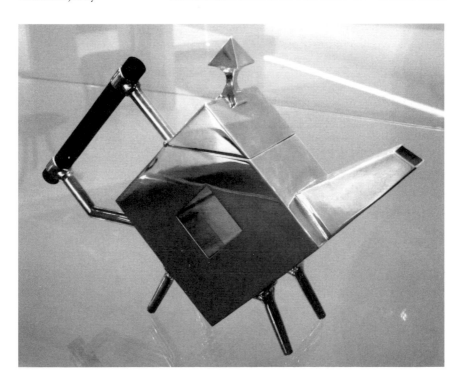

still a bit slow moving then, I have no reason to suppose they were not Couper's glass factory. It would seem that he was both an entrepreneur and a philanthropist. Besides consulting Christopher Dresser, he engaged workers from the glass-making area of Stourbridge in Birmingham, eventually passing the business on to his colleagues for just the rent.

The manufacture of art glass stopped in 1911 when the company moved into mirror manufacture. The firm was re-named the City Glass Company and the works and site were sold off in 1921.

Besides the exhibitions that I mentioned earlier, the contribution to design made by Christopher Dresser was acknowledged in an exhibition at the Victoria & Albert Museum in 2004. As far as I know, there have been no exhibitions of his work in Glasgow. I don't think that Glaswegians would come across Christopher Dresser by accident, as I did. Perhaps it is time to see his work in an exhibition in Glasgow.

Charles Eggar

Inventor of the Police Box

As I was researching Walter McFarlane's Saracen Foundry in Possilpark, I was intrigued by a reference to the first police box in Great Britain, which was invented by a Glasgow fireman. The inventor in question was Charles Eggar, who was a fire engineer with the City of Glasgow Fire Brigade.

Eggar was awarded the patent for his box in 1891 to 'provide communication of visible signals and establishing electrical and telephonic connection between central, town and district stations'. The design was based on cast-iron panels used in the street toilets then in use and also produced at the Saracen Foundry.

The box contained a telephone provided by the National Telephone Company. At that time, the General Post Office did not exist and it was left to private companies to develop telephone systems. It wasn't till 1911 that the new GPO[5] took over the 1,565 existing telephone exchanges[6].

[5] Glasgow has always been in the forefront of telephony and had the very first telephone exchange in Great Britain. This was the Glasgow Medical Exchange in Douglas Street, opened by David Graham in 1879. While it was originally for the medical profession, Graham established more exchanges, as did the Bell and Edison Telephone Companies. These would eventually be combined with the National Telephone Company and become the GPO.

[6] The first telephone switching device was invented and patented by another Glaswegian, David Sinclair, in 1883. He was an engineer with the National Telephone Company in Glasgow. His system allowed a subscriber on a branch exchange to connect to any other on the system via an operator situated at a central exchange. This cut out the need for an operator to connect at the branch exchange. A six-line exchange was set up in Coatbridge where, coincidentally, I served my apprenticeship in the Pye Telephone Manufacturing Company factory.

The first electronic exchange opened in Bishopton, Renfrewshire, in 1968. Having visited the Glasgow exchange in Bishop Street when I was a wee boy at primary school, this new, all-silent exchange was a real wonder when our apprentice group visited it just after it opened. The original Dial House was full of female telephonists and was a riot of voices and clacking telephone connections.

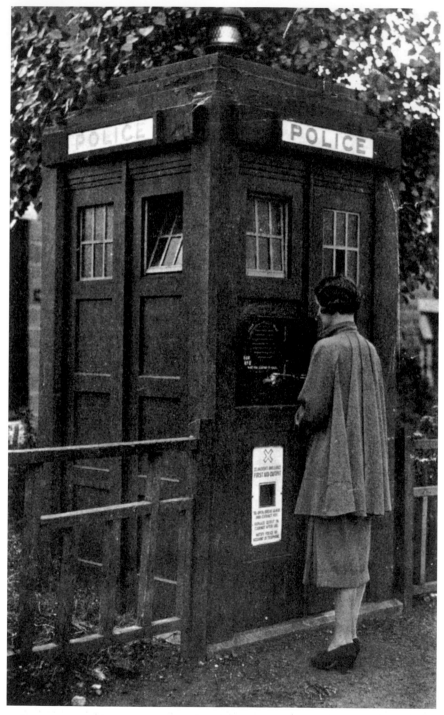

Gilbert MacKenzie Trench police box

By that time, many of the networks had amalgamated into the National Telephone Company.

The box was demonstrated to members of the Glasgow Corporation and the Chief Constable and was explained to them by the Firemaster at the time, William Paterson. The box was adopted and by 1931 there were more than ninety on Glasgow Streets.

There were two sets of keys for every box, one kept by the beat policeman and one by a local trustworthy member of the public. I wonder how they decided that?

While the records show that the patent belongs to Charles Eggar, there was obviously some discussion on this as the December minutes of the City of Glasgow Watching and Lighting Committee asked the clerk to prepare a deed that would transfer the ownership of the patent to the City Commissioners.

Originally Eggar's box was illuminated by gas lamp, presumably lit by the 'leeries' as they were lighting the other street gas lamps. The gas lamps were eventually replaced by electric lights. The distinctive red boxes themselves were replaced in the thirties by a new standard box. The instigator of this move was the new Chief Constable of Glasgow, Percy Sillitoe[7], who had just arrived from Sheffield, where the new boxes had been installed. The new box had first appeared in London in 1929 and was designed by Gilbert MacKenzie Trench. The new boxes used Ericsson telephone equipment. This Glasgow version also had a St Andrew's Ambulance first aid outfit, which can be seen on the bottom left-hand side of the box. I wonder if they can still get me for opening the telephone door and shouting sweary words into the phone. We used to do it when we were wee boys.

[7] Percy Sillitoe was an extraordinary man. He is credited with modernising the Glasgow police force and with putting a stop to the Glasgow razor gangs of the 1930s. He made policemen more recognisable by use of what became known as 'Sillitoe Tartan', the black-and-white band on police helmets and caps. From his Glasgow position Sillitoe went on to a wartime joint-planning force in Kent and then became Director General of MI5 in May 1946.

Hannah Frank

Artist

I am not entirely sure whether I had ever heard of Hannah Frank before I came across and bought one of her drawings around 1973. I certainly was aware of Charles Frank in the Saltmarket as I would often look at the expensive telescopes and binoculars in the shop window.

But it was in 1973, when I was in what was then called Arnott Simpsons in Buchanan Street, that I discovered Hannah Frank. I was home from university and hunting for a Christmas present for my parents. There, hanging in a row, were several Hannah Frank drawings and I was immediately taken by them, having difficulty choosing but finally going for *Moon Ballet*. I was struck by their clear, fluid lines and the balanced contrast of black against white. The drawing is still hanging in my parents' house.

Hannah Frank was born in Glasgow in 1908 to Russian émigré parents Charles and Miriam. Charles had been a mechanic and went on to open his famous shop at 67 Saltmarket. He sold and repaired photographic and scientific equipment.

Hannah went to Strathbungo School, Albert Road Academy and then Glasgow University, where she graduated with an Arts degree in 1930.

Following attendance at Jordanhill Teacher Training College, Hannah taught for some years, including at Campbelfield School in the East End. During this time she attended classes at the Glasgow School of Art. She married Lionel Levy in 1939. Lionel was a science and maths teacher, as was my father. I wondered if they had met, as they were of a similar age.

It was when she was seventeen that Hannah started to produce her black-and-white drawings under the pen name 'Al Aaraaf'. Al Aaraaf is the title of a poem by Edgar Allan Poe and was the name given by the

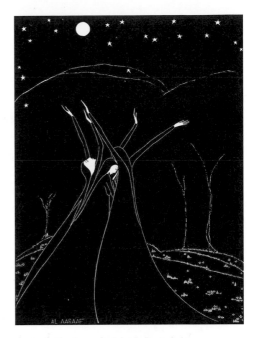

Right: Moon Ballet

Below: Glasgow University Jewish Society Zionist Branch Camp; Hannah is on the front of the bike

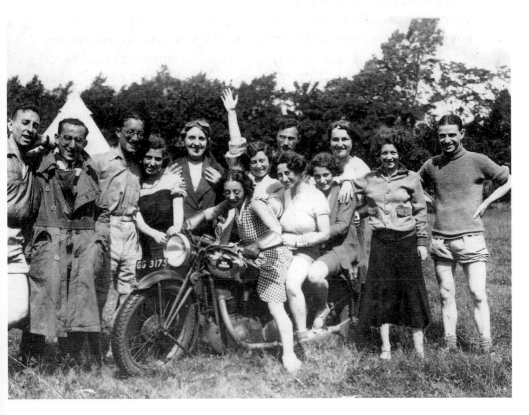

Danish astronomer Tycho Brahe to a discovery in 1572 of supernova, which appeared to grow brighter only to suddenly disappear after a year and a half. It is also, in Arab lore, that place midway between heaven and hell where souls wait for God's forgiveness to proceed on.

Hannah took to sculpture in 1950, studying under Benno Schotz. She has exhibited her work through the Royal Academy, the Royal Scottish Academy, and in the Royal Glasgow Institute of the Fine Arts. She continued to work up till the 1990s when she moved into a Glasgow care home with her husband.

She was a member of the Glasgow Society of Women Artists, who have said that 'her work has been called the last link to Art Nouveau and the Arts and Crafts Movement'.

Throughout her long life Hannah was an active member of the Glasgow Jewish community. Both she and her husband were members of the Committee of the Hebrew University and she contributed work to Jewish organisations. She died in 2008. Subsequent exhibitions have shown her continued and growing following.

Hannah Frank – Footsteps on the Sands of Time, edited by Fiona Frank and Judith Coyle, is a fine record of her life's work.

Will Fyffe

Comedian and Singer

You would be hard put finding someone in Scotland and even beyond who has not heard of 'I belong to Glasgow'. That song, written, composed and sung by Will Fyffe, is surely as Glaswegian as Glasgow itself. Only slightly less known is the composer.

Will Fyffe loved Glasgow and was loved by Glaswegians. He certainly knew the working man. It might be said that if he was glorifying drink, he was reflecting the plight of many a Glaswegian whose escape from poverty and a disintegrating city was the bottle.

I can't remember when I first heard about Will but I do remember my father explaining 'Twelve and a Tanner a Bottle' to me, possibly when he was singing it, as he often did. It was probably written in 1920, as on 19 April the price of whisky was put up from ten shillings and sixpence to twelve shillings and sixpence. It caused uproar and this song, written and sung by Will, was famous at the time.

Some of you will already be raising your hands in horror, as Will Fyffe did not actually belong to Glasgow but to Dundee, and from a more privileged background than that portrayed in some of his songs. His mother actually worked as a piano teacher, and his father was a shop's carpenter with an interest in entertainment. He was born in a tenement at 36 Broughty Ferry Road in Dundee in 1885.

While he was a Dundonian, Glasgow was his adopted city and when he died tragically of a fall from a window after an operation in 1947, he was interred in the city's Lambhill cemetery.

There is a story that in Glasgow, where he was hugely popular, the Empire Theatre ran a Will Fyffe competition. Disguised as himself, he came second singing 'I belong to Glasgow'. Will wrote the song, after

meeting a drunk in Glasgow's Central Station. Apparently he was going on about socialism and drink at the same time and when Will asked him if he belonged to Glasgow, he said that, 'At the moment, Glasgow belongs to me.'

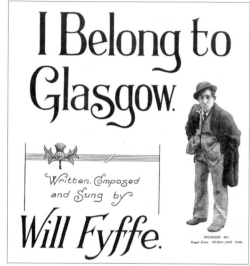

Above left: 'I belong to Glasgow, Dear old Glasgow Town'

Above right: 'If your money, you spend,
You've nothing to lend,
Isn't that all the better for you'

Ella Glaister

Author of *The Glasgow Cookery Book*

Having been required recently to make a large pot of Spaghetti Bolognese, where else would I turn for a workable recipe than to the only book that can guarantee a proper result and which has done so over several generations?

The Glasgow Cookery Book has been in our house for several decades even though my wife, the main cook, does not come from Glasgow. I was aware of how famous 'the Purple Book' is and that it has travelled the world with those emigrating. Several hundred thousand copies have been sold and a Centenary Edition was published in 2009. While the revised edition recognises modern weights and measures and changing trends, it is nevertheless a treasury of Scotland's favourites, including leek and potato soup, Dundee cake and shortbread. Thankfully it has dropped dripping and sheep's heid broth!

With my inquisitive brain attuned to searching for subjects for my own book, I wondered idly who had written *The Glasgow Cookery Book*, if indeed it had been one person. What I found was that it had been put together from lecturers' course notes, but the person behind its publication was Ella Glaister. Ella was the principal of the West of Scotland College of Domestic Science, which became known affectionately to Glasgow citizens as 'The Do (or Dough) School'.

The Do School came about in 1908 through the amalgamation of two institutions: the Glasgow School of Cookery and the West End School of Cookery. The college actually started off in 86 Bath Street, near to where Watt Brothers is now. Through appeal, the present building in Park Drive was planned and building started in 1913.

The college has had a long and respectable history and in 1975 it

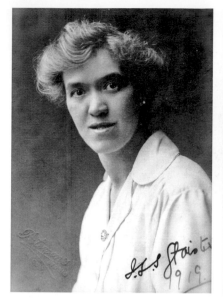

Above left: Ella Glaister

Above right: The Glasgow Cookery Book
'*Miss Glaister stated that she was preparing a new book of recipes, which are used in training, and which she hoped to have in the hands of the printers soon.*
– College Cookery Committee, 16 June 1910

was renamed the Queen's College, Glasgow, honouring its patron, since 1944, Her Majesty Queen Elizabeth II.

The college was for the training of teachers of domestic science as well as providing instruction in areas such as needlework and cookery to the general public and domestic servants. I can attest to this in my own small way because when I was a small Cub Scout in Anderston, we would make our way to the Do School to learn sewing and other skills. I am proud to say that after examination at the college I received my Wolf Cub Homecraft Badge!

During both World Wars, the college was instrumental in helping the military and the civilian population cope with the demands of catering for large numbers and of cooking with rations and food shortages.

Following the First World War, Ministry of Labour courses were provided for war workers and widows. These included cookery, laundry, dressmaking and housekeeping skills. The college also acted as a central training place for unemployed girls under the schemes of the Central Committee for Women's Training and Employment.

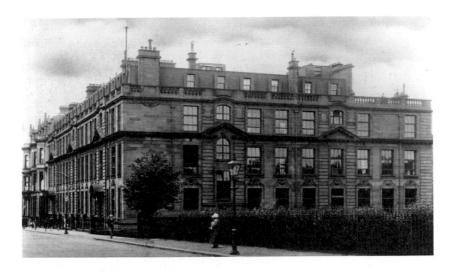

Clearly the creation of such an important and prestigious institution was a massive undertaking and would require strong leadership. At that time, I would also imagine that in a male-dominated world, considerable strength of character, as well as management skills, would be required to see the project through to completion, particularly as the First World War was on the way. While she was not in post to see the occupation of the new building, the person who saw the implementation of this great Scottish institution was Ella Glaister.

While she was principal at the college only from 1908 to 1910, she was clearly a driving force. Ella was a Glaswegian and the eldest of the six children of John Glaister and Mary Scott Clarke. John Glaister was an eminent physician who was Glasgow University's Regius Professor of Forensic Medicine and Public Health. Ironically, her parents were both to die within hours of one another in the Glasgow influenza epidemic in 1932.[8]

[8] I was intrigued enough to do a little bit more research on Ella's father, who had died in 1932 in the influenza epidemic. Being a professor of public health did not help. It was he who introduced postgraduate degrees in Public Health and Forensic Medicine. He was famous for presenting evidence at the trial of Oscar Slater for murder in 1909. The 1960s television series *The Expert*, starring Marius Goring, was based on John Glaister. I remember it well.

What also interested me was that a favourite of mine, who wrote the stories on which *Dr Finlay's Casebook* was based, was A. J. Cronin. Graduating in medicine in 1919, he went on later to complete the Diploma in Public Health, one of the important introductions of John Glaister. Many of A. J. Cronin's books are based on public health issues and it is generally accepted that *The Citadel* was a plea for a national health service. Interestingly, A. J. Cronin had worked together with Aneurin Bevan at the Tredegar Cottage Hospital. It really is a small world.

In March 1908, Ella was appointed to run the Glasgow School of Cookery, taking over from the well-known Grace Paterson. When the Glasgow School merged with the West End School, she was appointed principal. Following her term as principal she became Chief Inspectress in Domestic Science for Scotland, a prestigious job at that time.

She was unmarried when she was principal of the college but she subsequently met Professor Harold Addison Woodruff, a widower who had two young sons. Harold was to become a veterinary pathologist and bacteriologist at Melbourne University. They married at Queen's College, Melbourne, in 1919.

Ella died in 1954, but during her time in Australia she continued her pioneering work in the field of domestic science education. She was a founder of the Australian Invergowrie Homecraft Hostel and was its chief examiner from 1928 to 1949. The institution still exists as an educational trust. She was also a founder of, and councillor of, the Emily McPherson College of Domestic Economy, now part of the Royal Melbourne Institute of Technology.

Following Ella's death, Harold Woodruff moved to Scotland and died in Edinburgh in 1966. For interest, his two sons from his first marriage became eminent physicians. Michael Woodruff carried out the United Kingdom's first-ever kidney transplant at Edinburgh Royal Infirmary in 1960.

Meanwhile, the West of Scotland College of Domestic Science went from strength to strength. In the 1920s it began to focus on the diet, establishing courses for nurses and prospective dieticians. This included subjects such as bacteriology, hygiene and biology along with the more traditional cookery.

In 1960 it was decided that lower-level courses would become the responsibility of the growing number of further education colleges, with training at a higher level being provided by the college. Courses now became available to male students.

The college continued to widen its programme, introducing or taking over health and medical related courses from other institutions. This included physiotherapy, orthoptics, radiography, chiropody and occupational therapy.

In 1993, Glasgow Polytechnic and the Queen's College, Glasgow, amalgamated to form Glasgow Caledonian University.

William Harley

Entrepreneur and Supplier of Water

I am an 'Anderston Man' and as such I take a great interest in anything historical that happened in that area, or in adjoining areas that were also my stomping ground when I was a child. I knew a lot about the Glasgow water supply from Loch Katrine but it was a surprise to learn about the place of William Harley in the saga of providing water to the growing city.

William Harley had a bakery in Bath Street. Now I do remember in the 1950s a bakery, at the corner of Bath Street and Holland Street, I think, where we would go late at night to get hot rolls being prepared for the morning. Whether or not this was Harley's bakery I don't know, but I like to think that I had a link with this fascinating man.

In 1800, the city was growing fast and there was a dire need for clean water. For Glasgow the sources of water were the Clyde, the Molendinar and Camlachie burns or a small number of private and public wells. As the city expanded dramatically, these wells became polluted and with the slow speed of extraction by bucket, long queues formed. William Harley seems to have been a man with great imagination and limitless energy who emerged with a solution to the problem.

From Glendevon in Perth and Kinross, he was a weaver who, in 1789, moved to Glasgow, still working in the weaving trade. The following year he had learned so much that he set up in business on his own, establishing his own workshop. In 1794 he started making turkey red gingham. This was a colour of that fabric which was unknown in Great Britain. Much of this was exported to the Americas and to the West Indies.

He was a public-spirited citizen and was involved in establishing church schools in the Briggait, ensuring the education of all children in Glasgow. He was also involved, along with Robert Haldane, in

establishing Congregational churches, including Sannox in Arran in 1806. The great-grandparents of Prime Minister Harold MacMillan were part of that congregation.

His involvement with the city led him to buy Willowbank in Sauchy Haugh, near what is now Blythswood Square, which was a rural area in those days. From a good flowing spring in the grounds of Willowbank he led a pipe to the top of West Nile Street, from where his carts distributed water to the city at a halfpenny a stoup, or pail.

While this enterprise continued for some time, as the city grew it was clear that there was going to be competition and the development of a more effective system of water supply. The story of that is covered in the chapter on Robert Stewart.

But back to William Harley. So far, he has been shown to be an active churchman, an educationalist and a public-spirited carrier of water.

This was the age of the pleasure garden. Vauxhall and other pleasure gardens existed in London and other cities. These were areas of beauty which provided walks in flowered and fragrant avenues away from the stink of the streets. They were areas for trysting and for watching fireworks, listening to music, eating and watching illuminated fountains. Well, Harley attempted to emulate this at Willowbank by creating a pleasure garden for Glasgow. If London's professionals and merchants had the time and money to pursue their leisure, then why not Glasgow?

So he set to, providing gardens with a bowling green, arbors, a summer house, a folly and an observatory. This folly was a 30-foot tower from which he used to look down on his workers in the fields and gardens. It was also used for a short time by the famous Glasgow physicist Dr Andrew Ure as an observatory.

At his reservoir at Blythswood Hill, he opened baths and covered the Enoch Burn. This was where Bath Street is now and how it got its name. I had always assumed it was named after Bath. Apparently he also grew strawberries and gooseberries here and on Garnet Hill, and these were accompanied by cream from his own cows at Willowbank.

The pleasure gardens waned in popularity and Harley moved with the times and was involved in planning the redevelopment of the area, which would become Glasgow's equivalent to Edinburgh's New Town and included Blythswood Square and the surrounding streets of St Vincent Street, West George Street and Sauchiehall Street.

This might be considered work enough to be considered flourishing but it seems that the provision of cream for his strawberries was only

part of his dairy enterprises. At Willowbrae he had kept one cow for the provision of milk to those attending his baths but demand for his milk grew and so did the herd, eventually reaching 300 in 1814.

But his interest in cows did not stop simply at the provision of milk because it seems now that he was a pioneer of farming principles and practices. A 1919 American publication written by Paul Heineman, PhD, of Cornell University, reported on Harley's city farm:

Most interesting is a description of a sanitary dairy, the Willow-bank dairy, in Glasgow, owned by William Harley. The object of this dairy was to furnish a perfect milk to the population of Glasgow, and we find that Harley recognized a number of points as important for his purpose, points which sanitarians are contending for to this very day. The stables were large, well aired, well lighted, and clean. The cows were kept well fed and clean.

The best obtainable vessels were employed and the milkers had to be clean. Suitable food was selected and dry fodder was given only after milking. Accurate records of each cow were kept to ascertain her productiveness. The manure was promptly removed from the stables and spread on the farm as fertilizer.

However, after a number of years of prosperity, the enterprise failed due to the financial depression following the Napoleonic War, and it was not revived because of the apathy of the public. Milk was milk in those days as, unfortunately, it still is with many people today. The quality of the supply sold by Harley was an exception.

The majority of producers and dealers adulterated the milk in a shameless manner. In the salesroom of a dairy a pump — "the cow with the iron tail" of Dickens — was an almost universal necessity to aid the dealer in filling his cans with water. Not satisfied with diluting the milk, the dealer would remove some of the cream before selling the product. Prevention of these habits was difficult in those times, since reliable methods of testing milk were not known. It is true that a lactometer had been invented in the last decade of the eighteenth century, but its value was not appreciated. These abuses led to the enactment of a law in 1860 entitled : "An act for preventing the adulteration of articles of food".

His fame spread far and wide and in 1895 the *New Zealand Otago Witness* reported that his system of 'house feeding' with chiefly hay and grasses, supplemented by distillery draff and bean meal, produced as

much milk as 5 acres pastured in the ordinary way. It seems that Harley was pioneering the practice of factory farming, keeping cows indoors and feeding them concentrated 'artificial' foodstuffs rather than grass. It was reported that the beasts were well fed, in comfortable, sanitary well-ventilated buildings and had access to a yard where six cows could exercise for one or two hours per day.

While we may not have a high opinion of factory farming today, the methods advocated by Harley were revolutionary in that he seems first of all to have recognised the connection between clean and safe milking practices. If milk was to be provided safely in large quantities, the production would have to be efficient. The fact is that transport at that time from areas outside the city would have been very difficult. His methods seemed to have provided a solution to the problem. His approach to wholesome foods was also the reason for him being asked to open a bakery and this provided good quality bread far up the West of Scotland.

So it appears that Harley was making a name for himself as a pioneer of dairy techniques and, in fact, he wrote a book about it and this was offered to the public by subscription, advertised in the *Literary Gazette* of 1828. The book appears to have been well received:

Harleian Dairy System;

And an account of
The various methods of dairy husbandry pursued by the Dutch.
Also, a new and improved mode of ventilating stables.
With an appendix, containing useful hints (founded on the author's
experience) for the management of hedge-row fences, fruit trees, &c;
and the means of rendering barren land fruitful,

by
William Harley

This book does not stop at dairy production but also covers the use of manure in the fertilisation of fruit crops. He offers advice on fruit cultivation, too, and the mechanisation of animal feeding.

He was obviously advanced in his thinking and respected in many agricultural quarters. So much so that he took up an invite in 1829 to visit Russia to establish a dairy farm for Tsar Nicholas in St Petersburg.

Unfortunately, on the journey he took ill and died. There is little known of his family but he had at least three sons, the third of whom died on Campobello Island in Canada in 1834.

Tom Honeyman

Director of Glasgow Art Gallery

If you lived outside Glasgow for any amount of time and are a lover of the arts and science, you would very soon appreciate the commitment that Glasgow has shown to its culture. The existence of the Glasgow Concert Hall, the Museum of Modern Art, the West End Festival, Glasgay, Mayfest and a host of other buildings and events are testament to the cultural spirit of the Glaswegian. We have always protected and encouraged innovation in arts and crafts and in music.

There are always those who would call art elitist and too costly. Without champions and defenders, we would not have the galleries and collections that are among the best of any city in the world.

As a child in Anderston, the Glasgow Art Galleries were on my doorstep and the People's Palace was on the way to my granny's. Whether with my father on our Glasgow wanderings or with friends or on my own, the galleries were part of the weekly itinerary, if only to be collared for going round and round the circular doors at the entrance. The galleries were a wonder to me, particularly the ship and engineering models that would move when you pushed a black button at the bottom of the case.

The ship models moved out of the galleries and are now placed in the wonderful new transport museum, again a credit to the city. The Glasgow Art Gallery has now been completely renovated and is world class. And back in the Art Gallery, taking pride of place is *Christ of St John of the Cross* by Salvador Dali, controversial when bought but now a major asset, financial and culturally.

The Burrell Collection is now proudly displayed in its own palace in Pollok Estate, a wonderful place where I saw The Age of Van Gogh

Above: Glasgow Art Gallery and Museum

Right: The Aviary, Clifton, in the Burrell Collection, by Joseph Crawhall, one of the Glasgow Boys

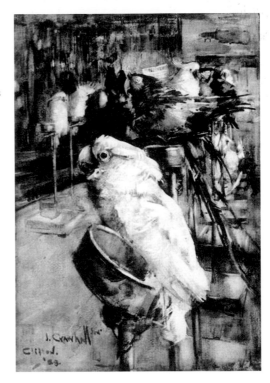

exhibition in 1990. The gallery is a huge tourist draw but, as with all of our galleries, it is visited just as much by Glaswegians.

The Burrell Collection had a difficult time over the years. Sir William Burrell, when donating the collection to the city in 1944, stated that it should not be housed within the city but at least 16 miles' distance from the centre to protect it from the dense smog of the time. It took twenty-five years and a few modifications to the terms to find and build a suitable gallery. Despite this, aspects of the collection were regularly put on display and I particularly remember visiting 'Stained Glass from the Burrell Collection' at the Art Galleries.

What I did not know when visiting *Christ of St John of The Cross* or exhibitions from the Burrell Collection as a wee boy was that these were only made possible by the efforts of one man. That one man was Tom Honeyman, whose life and persistence make him worthy of being called a Glaswegian with a flourish. Others thought so too, as he was a worthy recipient of the St Mungo Prize[9] in 1943.

Tom Honeyman was born in Glasgow in 1891, the son of engine driver Thomas Honeyman and Elspeth Smith. He trained to be a doctor and completed his degree in 1909 before he served in Salonika and India during the First World War. He returned from the war to a general practice in Dennistoun in Glasgow.

I like to think of Tom Honeyman being influenced by the culture of art and crafts in the city as he decided to become an art dealer in London. During his medical studies he had also attended evening classes at Glasgow School of Art, where he must have rubbed shoulders with many artists.

In 1929, he finally gave up medicine to join the art dealers Reid & Lefevre, who were then based in West George Street. He had met an old friend, Duncan MacDonald, who offered him the job of running the Scottish branch of the company. When he moved to London with the company, he became immersed in the world of art, meeting Dali and

[9] Since 1940, the St Mungo Prize of a gold medal and £1,000 has been awarded every three years to a Glaswegian who has done the most to beautify the city, to increase the well-being of the citizens, to purify the atmosphere, to foster better relations between all classes, to extend cultural and educational development, and to bring Glasgow into honourable prominence.

The funding of £13,000 was originally supplied by an anonymous donor, but following his death in 1949 he could be named. He was Alexander Paterson Somerville, who was a businessman and also a watercolour artist. Besides Tom Honeyman, the list of winners have included Sir William Burrell, Sir Alexander Gibson of the Scottish National Orchestra and George Parsonage of the Glasgow Humane Society.

Matisse as well as collectors who would later gift their collections to Glasgow. The William McInnes bequest in 1944 included Cézanne and Van Gogh. The Cargill bequest included Corot, Seurat and Courbet. The jewel in the crown, however, was the 1943 Burrell Collection.

In 1939, he was appointed by Glasgow Corporation to the position of Director of the Kelvingrove Art Gallery, a position that he held for fifteen years. He was to bring a revolutionary approach to the galleries, making them a delight to visit as well as bringing international recognition. He also took them out to the people, establishing the Glasgow Schools Museum Service.

His time at the gallery was not without controversy. When I was a small boy, our school visited the Art Gallery to see the new *Christ of St John of the Cross*. It was quite famous and over time was to become an icon for the city. What I did not know at the time was the controversy behind the purchase and the ongoing dislike that some people had for its prominence. I saw it before it was savagely attacked by a maniac with a brick in 1961 causing a great deal of damage. It was restored and is now a centrepiece of the reopened gallery. In 2006 it was voted Scotland's favourite painting.

When Honeyman decided to make the purchase it cost £8,200, which was an enormous sum to pay for a painting at that time. This caused controversy, as did its style and religious content. However, the painting went on to be a major attraction and brought in, through royalty payments, far in excess of its original cost. It still does. This purchase demonstrated Tom Honeyman's forward thinking and marketing ability, which was just as important as knowledge of art. This reputation was instrumental in attracting to Glasgow, in 1944, the wonderful collection of ship owner and philanthropist Sir William Burrell, also a recipient of the St Mungo Prize.

But Tom Honeyman's contribution did not stop at Glasgow Art Galleries. He was an ardent supporter of all things artistic in the city. Along with the playwright James Bridie, he was instrumental in establishing the Citizen's Theatre Company in 1943. He also established the Glasgow Schools Museum Service, served as Chair of the Scottish Tourist Committee and was rector of Glasgow University. Tom died in 1971.

If you think that Tom Honeyman may have had an easy time in all that he achieved then I can tell you that his achievements are even more astounding, as he had to fight all the way to achieve his great memorials. There was a great deal of resistance to the idea of buying the Dali. The

Burrell Collection was so mired in difficulty that it took forty years to find a final home. Yet Tom Honeyman seems to have laboured away with his team, stoically and with humour, generally putting up with obstructions from committee convenors and councils. He has told all of this in a matter-of-fact way in his own book, *Art and Audacity,* published by Collins in 1971.

This book, which is a fascinating account of his team's work, should be required reading in leadership courses in Scotland. His final chapter is almost a lament that on having to retire because of ill will from specific members of the council, his mission had failed. In fact, it had not failed. He had turned the Art Gallery into a respected city and European institution. He had brought the wonderful Burrell Collection and set in train the Citizens and the Scottish Tourist Board. Some flourish.

Showing his foresight, he argued very strongly for the Royal Exchange Building in Exchange Square, owned by the Council, to be turned into an art gallery in the city. His idea was rejected and it was turned into a library. But guess what? We now have the GOMA, the Gallery of Modern Art. He would have loved it.

He was also concerned for the environment and tried to get something done about the River Kelvin which runs past the gallery. This was polluted by the paper mills further up the river at Dawsholm. He was organising an exhibition of sculptures in the area between the galleries and overlooking the river. He suggested it be advertised 'Scum and see the Sculptures'. It was not well received by the establishment. The tabloids would have loved him.

On reading his book, I can also see that he was a man who had a deep concern for the city. But he was a man with vision who could see the inter-relationships of art and science. He was an entrepreneur, but he was modest and in his book he gives as much credit to his teams and peers. This is all echoed by Jack Webster's book on Tom, *From Dali to Burrell – The Tom Honeyman Story*. It is a good read.

Jack House
Writer and Journalist

'Jack House, BBC quiz expert, with a devotion to Glasgow and its
citizen's which scarcely stops this side of idolatry, was always willing to
lend a hand. We differ in some minor issues. – he is an authority on pubs
and I lean to coffee houses – but we are united in our concern for making
known the true image of Glasgow and the quality of its people.'
Tom Honeyman 1971

How could I write a book about Glasgow and its people without
mentioning Jack House? I was brought up with Jack House – in the sense
that he wrote in our newspapers and appeared in television. He talked
enthusiastically about Glasgow as well as being a complete authority on
the city and its people.

Jack was originally from Tolcross but the family moved to Dennistoun,
so he attended Whitehill Secondary. His father insisted that he become
a chartered accountant but Jack wanted to be a writer and write he did,
starting as a journalist with the *Evening Citizen* in 1928. He went on to
write for the *Evening Times*, *Sunday Mail* and the *Sunday Post*.

During the war he joined the Gordon Highlanders but moved to, and
achieved the rank of captain in, the army film unit, where he worked
alongside Peter Ustinov and David Niven.

Jack published around seventy books, many of these humorous and
many about Scotland, its towns and its cities. He was also commissioned
to write company histories, *Pride of Perth, the Story of Arthur Bell
and Sons* being one I remember well. One of his most well-known and
successful books, still in print, is *Square Mile of Murder*. This included
the famous stories of Madeline Smith, who laced her lover's cocoa

Jack House and Glasgow Lord Provost Susan Baird

with arsenic; and Dr Edward William Pritchard, the Human Crocodile who poisoned his wife and mother in law and was also suspected of murdering a servant girl. He was found guilty and was the last person to be publicly executed in Glasgow.

Jack married Jessie Millar in 1937. She was the respected women's editor of the *Glasgow Evening News*[10]. They had no children and she died in 1974. Jack died in 1991. Jack was honoured with the St Mungo's Medal in 1988.

[10] The *Evening News* was published from 4 October 1915 to 17 January 1957. At one time its editor was the novelist Neil Munro and the writer George Blake was its literary editor.

Alonzo Kimball and John Morton

Sewing Machine Manufacturers

There can be very few people who have not heard about the Singer Sewing Machine. In Glasgow, although times are changing and memories are fading, there are still many people who could tell you that Singer had a huge factory in Clydebank producing their machines. In fact, the workforce was so large that they built a special station called 'Singer'.

The word 'Singer' became synonymous with the sewing machine, just like Hoover did with the vacuum cleaner. There was clearly a lot of competition for both these machines and it is generally accepted that survival of the fittest could be applied to the process of becoming the most famous and the most successful.

While I was researching a previous book on Glasgow, I happened across a reference to a sewing machine manufacturer based in the street where I went to school, Bishop Street[11], in Anderston. I was fascinated to learn that Kimball & Morton had manufactured sewing machines at number 82, later 21 Bishop Street, sometime between 1867 and 1955. The modern-sounding 'Oscillator' was introduced in 1886. They were most famous for 'The Lion' and for 'The Stitch in Time'. I love the names.

The company was established by Alonzo Kimball and John Morton, firstly at 11 Bothwell Circus, producing machines that could sew sails,

[11] Bishop Street was not a long street and was typical of Glasgow streets in which people lived cheek by jowl with factories, foundries and workshops. In Bishop Street in my time in the 1950s were my own school, which was a combination of Saint Patrick's Primary and Boy's School, which was a 'Junior Secondary'. There was a baker and a sausage-making factory, two carters with an associated stable, three pubs, a foundry, an engineering company, a telephone exchange and a builder's yard as well as a row of tenements that I remember were quite 'good closes'. It's no wonder I grew up with an interest in industry.

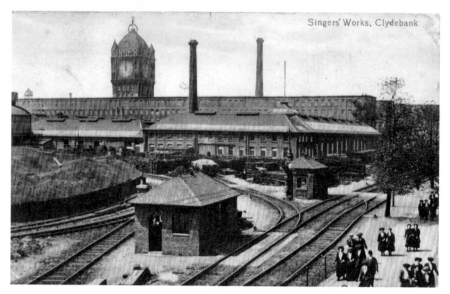

Singer Sewing Machine factory Clydebank, *c.* 1900

'The Lion'

Bishop Street, Anderston, *c.* 1900

sacking and tarpaulin, materials which were in common use in the city. In 1895, the address was given as 11a Norfolk Street.

From 1861 to 1865, Alonzo Kimball had been a manager for the Singer Company, based at 11 Buchanan Street. He had employed John Morton as a salesman and he went on to open a Liverpool office for the company. According to the International Sewing Machine Collectors Society, Alonzo may have taken the huff at not getting promotion. He started taking out patents in his own name and joined with John Morton in what was clearly a niche market, targeting the sewing of sail and other heavy cloths. The *London Gazette* records a patent being awarded to him in 1864 for 'Improvements in sewing machines'.

The new machines were successful and while not technically different, The Lion had a unique feature with the mechanism hidden within a bronzed cast-iron lion. When not in use, a dummy pair of front legs hid the needle. The company did well on its reputation for industrial machines for sewing sails and heavy cloths. It exhibited at the American Centennial Exhibition in Philadelphia in 1876, where it was the only British-made sewing machine to gain a medal. That's a flourish. And by the way, check your garages, as a recent estimate for one of these to be sold at auction was £25,000.

The records show that the company existed until 1955, no longer at Bishop Street and no longer making their own machines. They also went on to make bikes and mangles. Quite a flourish.

Sir Thomas Lipton
Tea Merchant and Yachtsman

You only have to look at the drawing from the 1903 Baillie to see that Thomas Lipton had a flourish. Glasgow has had a proud record of producing great grocers. Names such as Cochrane, Coopers and Henry Healy trip off the tongue in Glasgow, but while many of them are long gone, Thomas Lipton was to make both an international name and reputation which continues today. You can't go anywhere in the world without being able to buy Lipton's Teas.

Tommy Lipton was a marketing genius who also understood the need for quality and efficiency in the organisation and running of food shops. He also fully understood the need to control production as well as distribution and sale. In fact, he started what the major supermarkets now do, buying fresh produce directly from Irish farmers.

Thomas Lipton was born in the Gorbals on 10 May 1850 of parents who had arrived from Fermanagh. Thomas Lipton and Frances (Johnstone) were two of the huge influx of Irish immigrants to arrive and settle in the Gorbals and in Anderston at that time. They lived at 10 Crown Street and his parents had a grocery shop there at number eleven.

He attended St Andrew's Parish School from 1853 to 1863. He helped out his parents with work as a printer's boy and a shirt cutter. He also continued his education by attending the Gorbals Youth School in the evening. This small school in Elgin Street was eventually to become Hutcheson's Girls School.

At sixteen he signed on as a cabin boy on a Burns steamer between Glasgow and Belfast and took to a life at sea. On leaving the steamer company and having saved some money, he made his way to the United

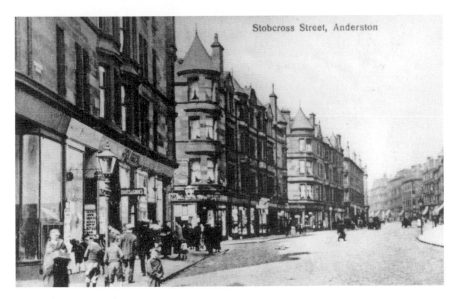

Stobcross Street, Anderston

Stobcross Street Anderston, *c.* 1900

States. Here he spent five years travelling and working. His experiences were to prepare him for a life of business. He worked as a door-to-door salesman, a book-keeper in South Carolina and in a grocery store in New York. In 1870, he returned to Glasgow and put his newfound ideas into practice while helping his parents in their shop in the Gorbals. His 'new fangled' ideas were not always appreciated so that's maybe the reason why he opened his own shop at 101 Stobcross Street the following year. This proved to be a success and was the start of a chain of stores across Great Britain.

He was successful in investments in the United States, but more importantly he saw falling tea prices as an opportunity to cut out the middle man and begin to sell reasonably priced tea to the working classes. He also understood the need to control prices at source. This led him to buying plantations and establishing the Lipton Tea brand. Lipton's Teas have been an unqualified success and are now owned by Unilever.

He was a real entrepreneur with a taste for the dramatic. His tea was to be a great success and he became a millionaire. This allowed him to indulge his passion for yachts and yacht racing. Between 1899 and 1930 he challenged five times, unsuccessfully, for the America's cup in successive versions of his yachts *The Shamrock*.

Lipton with Red Cross Nurses 'Sister Susies' aboard his yacht, Serbia 1915

A fascinating fact that emerged was that it was Thomas Lipton who started the football World Cup in 1910. The Sir Thomas Lipton Trophy was played for on two occasions in Turin. It was said to be the first World Cup, although there had been another competing claim in Turin in 1908. The Football Association of England refused to represent Lipton's competition. Undaunted, the great Lipton invited West Auckland FC, a miners' club from County Durham, to play against some of the most prestigious teams from Europe.

Triumphantly, West Auckland won in 1909, beating Swiss team FC Winterthur. They returned to Italy in 1911 to beat Juventus 6-1 in the final. They were awarded the trophy in perpetuity. The sad end was that the trophy was stolen in 1994 and never recovered. A replica is now held at the club. Not surprisingly, a TV drama was made of this amazing story in 1982. It starred Denis Waterman and Tim Healy. I remember it well. It's time we saw a film made of it.

Tommy Lipton was knighted by Queen Victoria in 1898 aged forty-eight and had also been made a baronet. However, the accounts are that he was an ordinary type of person without any snobbishness.

His legacy is indeed heroic. He helped medical organisations during the First World War, fitting out his yacht *Erin* as a hospital ship for the Red Cross and others. During his travels supporting and encouraging

'Work hard, deal honestly, be enterprising, exercise careful judgement, advertise freely but judiciously.' Thomas Lipton

medical staff overseas, he asked for no better conditions than local people had at those times. He wanted modest food and lodgings and joined the locals in their pursuits, such as fishing.

Thomas Lipton died in October 1931, leaving no family. He is interred beside his parents in Glasgow's Southern Necropolis. While we remember him for his business successes and his racing, we also should remember him for his gift to Glasgow. Besides his yachting trophies and his collection of papers and photographs of the America's cup, he gifted his entire estate to the poor of Glasgow.

For a final flourish, I must mention his advertising flair. He dropped leaflets for his shops from a balloon and hired a dozen plump ladies to march up and down outside the street carrying posters saying, 'We shop at Liptons.' A pair of pigs were also led round the streets marked 'Lipton's Orphans'. Some Flourish. Some Glaswegian.

Jimmy Logan

Actor and Theatre Impresario

Jimmy Logan was one of my heroes. Being brought up in Glasgow, where Jimmy and his family were an institution, just like the *White Heather Club*, I saw him in regularly in pantomime and variety shows at the Glasgow Alhambra. But unlike the *White Heather Club*, Jimmy Logan represented the true Glasgow and took Glasgow humour far and wide. For me, while I liked and respected him in pantomime, I thought that one of his best-ever performances was as a boss in Bill Bryden's *The Ship*, which involved the creation of a 67-foot-wide model of a ship inside Harland and Wolff's former engine shed in Govan during the Glasgow Year of Culture in 1990. This accommodated an audience of up to 1,200 and ended each night with the launching of 'The Ship'.

His journey to Eden Court in the dreadful winter of 1983 shows his showmanship and professionalism. It was a bleak winter night and snow had already been falling as we made our way from Dingwall with our small children to see the pantomime at Eden Court. During the show, Jimmy was required to use an electric wheelchair with headlights (you had to be there). During the show the house lights failed, as they often did during a snowfall.

Jimmy was absolutely brilliant in the way he stopped any panic and kept us laughing with his illuminated wheelchair. It was clear after a while that the lights were not going to come on again, so he skilfully oversaw the evacuation of the theatre using only the emergency lighting and his headlights. A Super Trouper. He was also famous for 'Lovely biscuits'.

Jimmy was born James Short, into a show business family in Dennistoun in April 1928. His parents were a music hall act, Short[12]

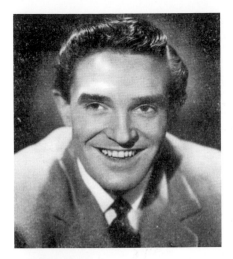

Jimmy Logan's
**METROPOLE
THEATRE**

PRESENTS

'Cupid
Wore
Skirts'
by Sam Cree

PROGRAMME ·· ONE SHILLING

Above left: 'Lovely Biscuits'

Above right: Jimmy Logan used a lot of work by Irish playwright Sam Cree

Left: Jimmy Logan's Metropole

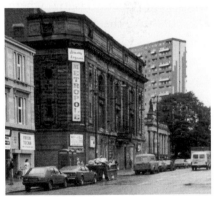

[12] I have to tell you a wee story here about Jack Short, Jimmy's dad. Jack was the man with the virtual big hook who would say 'Aye don't call us, we'll call you'. In the early 1980s, the Metropole was running the auditions and early heats of 'Oppornockity Tunes' (as it was called in Glasgow).

It so happened that the folk group that were us went for an audition and I can't remember why it was decided that everyone would wear a shiny blue suit with braid. By that time I had been relegated to 'manager' and was not at all unhappy to sit it out backstage. I'm going to pass over very quickly what happened on stage, except that Mr Short's hook came out quite quickly.

What I remember most about the whole strange affair wasn't so much the folk group in baby blue but the guy with the full Highland regalia that we got talking to in the dressing rooms. Nice enough guy, but such were ten a penny in those days of the *White Heather Club*. What was surprising was the fact that he volunteered that his chosen song for audition was going to be Blake's 'Jerusalem'! Of course this was before it, adapted by Vangelis, featured in *Chariots of Fire*, the film about the Scots Olympian Eric Liddell and fellow athlete Harold Abrahams. This was partly filmed in St Andrews and released in 1981 to great critical acclaim.

All stirring stuff, but I have to tell you that Jimmy Logan's Metropole at St George's Cross was far removed from England's green and pleasant lands.

We never got on to *Opportunity Knocks*. The world lost out, I feel. I could have had a career there!

and Dalziel. But Jimmy took his stage name from his Auntie Ella Logan, who was to become a hit on Broadway. His sister is the well-known jazz singer Annie Ross.

It had been Jimmy's ambition to run his own theatre and he did so with an offer to buy the Metropole, which he did, becoming the owner of the renamed New Metropole in 1964, a venture into which he put his life savings.

While the first years were good for Jimmy and his fellow Directors from the family, allowing them to invest in improvements, it became a struggle. The Corporation of Glasgow apparently failed to tell them that it was a listed building and refused planning permission for the redevelopment of an adjacent building owned by the company. The corporation had its own plans for the redevelopment of St George's Cross and the theatre didn't appear to figure in them.

One of the events that helped the survival of the theatre was the rock musical *Hair,* which ran for ten months, playing to 200,000 people. I was one of them. However, the theatre suffered from the 1972 blackouts ,during which shows had to be cancelled. The theatre closed and never reopened. In 1974, there was a fire caused by vandalism which virtually destroyed it. The bank finally took control and sold it to a developer. A block of flats now stands on the site.

In 1996, Jimmy was awarded an OBE for his 'Services to Scottish Theatre' and an honorary Doctorate of Letters at Glasgow Caledonian University in 1994. He died in 2001, not long after having set up the Jimmy Logan Cancer Trust for sufferers of cancer.

Tommy Lorne

Comedian

If I had wanted something named after me I think it would be something world enhancing or climate changing. I don't think it would be a sausage. For that's what happened to our next hero, or so it is claimed. It is probably more likely that he made the story up himself. On the other hand, the Lorne sausage has a place of great respect in the Glaswegian diet. It is the sausage of choice on the morning roll and what better base for a fried egg?

Tommy Lorne was one of Scotland's great music hall performers and appeared regularly in Howard and Wyndham's pantomimes. Originally from Fleming Street in the Cowcaddens, son of Irish Catholic parents, the family settled in Kirkintilloch.

Tommy was an intelligent boy and this intelligence took him with a bursary to St Aloysius College in Garnethill, following which he started a technical apprenticeship at the Blochairn works of the Steel Company of Scotland. However, it is clear that he had the stage bug. He said that he first appeared on stage in Kirkintilloch at the age of five and subsequently with the Port Dundas Court Juvenile Minstrels, singing and dancing. He performed at talent shows and as he became better known, teamed up with other artists; his longest lasting partnership was as Wallace and Lorne, with Billy Wallace. They toured Scotland on the variety circuits, eventually appearing at Harry McKelvie's Royal Princess's Theatre in the Gorbals. This was a famous and lavish pantomime lasting up to twenty weeks. The Royal Princess was to go on to become the Citizen's Theatre.

Lorne was Tommy's stage name as he was actually born Hugh Corcoran. There is a story that he actually wanted to be Tom E Lorne but the printers made a mistake! Like most music hall performers before

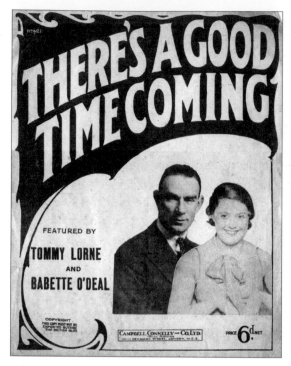

There's a Good Time Coming

and since, he adopted his own dress, mannerisms and sayings, although his dress was a bit exaggerated. He wore an oversized Glengarry bonnet, a kilt and jacket that were both too short, wore white make-up and talked in a high squeaky stage voice!

And it is probably the sayings that stick most of all. Even though Tommy Lorne was before my time, I remember well the sayings still being used and often by other comedians. Whether 'Sausages are the boys' had anything to do with Lorne sausages I don't know, but the phrase coined by him is still on the go and I remember Jimmy Logan using it. The other one was 'Ah'll get ye!' And I can see my father saying his most famous: 'In the name of the wee man'! I always wondered who the 'wee man' was and whether it was the same wee man he was going to see about a dog.

Among his stage appearances were *Sleeping Beauty* in 1929, *Goldilocks and the Three Bears* in 1930, *Cinderella* in 1932 and *Babes in the Wood* in 1933, all at the Theatre Royal. He also appeared regularly in pantomime in the King's Theatre, Edinburgh. Besides stage appearances, Tommy also appeared in a couple of short films, *The Lard Song* and *Tommy Lorne and 'Dumplings'*.

What I didn't know was the connection with Garngad (Little Ireland), where Tommy appeared many times in St Roch's Hall. Garngad was the home of my Irish Catholic grandparents and St Roch was their parish church. Tommy was a pal of one of the parish priests at that time, Father Edward Lawton[13]. When Tommy caught pneumonia and died in 1935, his funeral service was conducted there by Father Lawton. 3,000 mourners were at what was the largest funeral ever in Garngad. It was attended by the great Harry Lauder, who retired the same year.

Tommy worked himself to death and drank too much for his own good. He also had contractual difficulties with A. Stewart Cruikshank, Managing Director of Howard & Wyndham. The pressure in his final 1934–35 season of doing two shows of *Cinderella* a day contributed to his entry to an Edinburgh nursing home with exhaustion. At forty-five, he contracted pneumonia and died at 11 Ainslie Place, Edinburgh, on 17 April 1935. Tommy was buried in his parent's lair at the Auld Aisle Cemetery, Kirkintilloch.

Tommy married, on 10 November 1914, Mary Frances Ellard, daughter of Christopher Ellard, tailor. The couple went on to have three children: John (Jackie), Richard and Eileen. His military service, which started in 1917, was carried out in the Royal Field Artillery stationed in India on the North-West Frontier, where he entertained the troops in concert parties.

On 1 October, the BBC presented the great Stanley Baxter in a tribute to Tommy.

[13] Father Edward Lawton seems to have been a personality himself and greatly respected by the Irish community in the area now known as Royston. Apparently, the change of name from Garngad to Royston was the only battle that he did not win. He believed that Garngad was full of very talented people and that with proper support and motivation they could make their way in the world. He turned a plot off Milburn Street into a football pitch and opened a social centre. It was he who was behind the famous St Roch's Junior football club as he believed that the talented players in the Boys Guild team could move on more easily to senior football if there was a stepping stone.

It was he who persuaded the great names of show business to appear at St Roch's Parish Hall and who called these events 'Half a crown do's'. He became a lifelong friend of Tommy Lorne. My mother particularly remembers Tommy Morgan appearing and well remembers Father, later Canon, Lawton. His major coup was getting the Prince of Wales to open the Parish Halls in 1933. Apparently, they had met while visiting Lourdes Grotto.

People also remember his stout umbrella, with which he would berate errant husbands and delinquent youths. Another Glaswegian with a flourish.

The famous Celtic football player Jimmy McGrory was also from the Garngad and was bought his first pair of football boots by Father Lawton. Lawton also appears to have been instrumental in his signing for Celtic from St Roch's Juniors. Jimmy played for Celtic from 1923 to 1938 and was their top scorer with 550 goals. He still holds the record for the most career goals in British football. He was manager from 1945 to 1965, winning the League Cup, the Coronation Cup and League Championship. He was succeeded as manager by Jock Stein, but he was the Public Relations Officer from 1965 until his death in 1982.

Stanley said: 'In the long and distinguished history of great Scottish comedians there is one name that stands out particularly in my mind, that of Tommy Lorne. His star burned brightly, but briefly, in the early years of the twentieth century. My parents loved him, as did many Glaswegians, and in 1934 as an eight-year-old boy I was taken to the Theatre Royal to see him as Dame in *Babes in the Wood*.

Although he died only a year later and I was to see him no more, his hilarious and extraordinary stage persona is still etched in my memory. He was, rightly, a huge star in Scotland, and although he may be long gone I'd hate for him to be forgotten. So this is my tribute to the great Tommy Lorne entitled, in the words of his own, famous catchphrase: 'In the Name of the Wee Man.'

Just before I go, and I can't prove this, but it may be that Tommy Lorne is responsible for the BBC being called 'Auntie'. No-one seems to know the reason why, but Tommy Lorne produced a record for the BBC in 1922 called *Auntie Aggie of the BBC*. It was re-issued on an LP in 1972.

R. S. McColl (Toffee Bob)
Footballer and Sweetie Shop Owner

You probably think that I am away to talk about sweeties and newspapers, but you would be wrong – partly.

Robert Smyth McColl is considered to be one of Scotland's greatest footballers. He played as a centre forward. Born in 1878, he joined Queen's Park in 1894, when he was sixteen, from Benmore, a defunct Mount Florida club. His first game was in a 2–1 win against Rangers in a Glasgow Merchant's Charity Cup match at Cathkin Park. Queens Park went on to be beaten 2–1 by Celtic in the final.

According to the International Federation of Football History and Statistics, Robert McColl 'was a scorer with a deadly shot, but also an exemplary team-mate and excellent at passing. He made his international début in Dundee on March 21, 1896, when he played against Wales without scoring, but he scored ten times during the next five full internationals. On 14 April 1900, he reached the Scottish Cup final with Queen's Park FC, but lost 3:4 to local rivals Celtic.' By the way, is it not a great thing that we have a federation to record such detail? Have a look at their website, www.iffhs.de.

After eight years at Queen's Park, he was tempted to join Newcastle United although he was also approached by Derby County, Blackburn and Liverpool. In 1905, he signed for Rangers, where he stayed until 1907 before returning to Queens Park, where he remained until 1910. During his time in football he gathered thirteen caps for Scotland playing centre-forward. In the game against England in 1900 he scored a hat-trick, Scotland eventually winning 4–1 at Celtic Park. He retired from football at thirty-two, but not before scoring nine goals in his last three games.

In 1901, possibly in wise preparation for retirement from football, he opened a sweetie shop in Albert Drive with his brother Tom. This company expanded rapidly to become an institution in Scotland. They opened a factory in North Woodside Road in 1916, at which time they had thirty branches. They also had a chain of restaurants with three very popular ones in Glasgow. In 1933, Cadbury Brothers took a controlling share in the business. Both brothers remained with the new company during its growth to 180 branches by 1935. They retired in 1946.

Robert died in 1959 and is buried in Cathcart Cemetery.

R. S. McColl became part of T. M. Retail, the owner of Britain's largest chain of newsagents. The name R. S. McColl has been retained in Scotland.

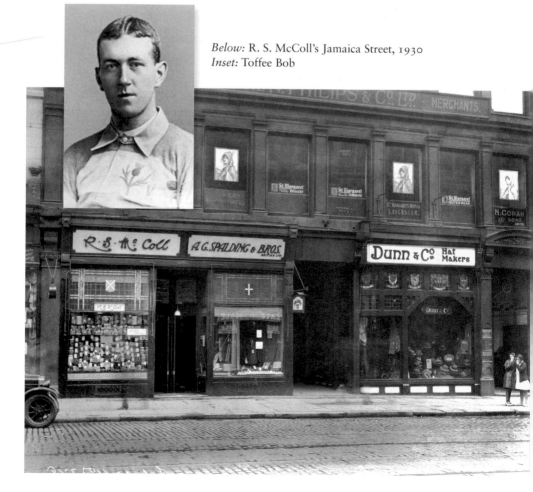

Below: R. S. McColl's Jamaica Street, 1930
Inset: Toffee Bob

R. S. McColl Glasgow Restaurants

Walter McFarlane

Industrialist and Social Reformer

If you take a walk through MacQuarie Place in Sydney, Australia, you will come across a canopy for a fountain. Although the fountain has been removed, the canopy is a link between Glasgow and Australia, between this new century and the end of the nineteenth century. For this canopy came from Walter McFarlane's Saracen Foundry in Possilpark, Glasgow, one of eight ordered for Sydney in 1870.

As the Empire expanded and the colonies throughout the world grew and settled, they looked towards comforts and reminders from home. They also celebrated the establishment of their new homes and cities with statues and municipal ornamentation. They particularly wanted cast iron and where else would they get it from but from their homelands? If there were foundries in the colonies then they were small or primitive. That would change, but in the meantime orders were placed with British foundries. One of the most productive and celebrated was the Saracen Foundry.

Walter McFarlane was born in Clachan of Campsie, north of Glasgow, in 1817. His first employment that we know about was with a jeweller, William Russell, in the Trongate in 1830. It is recorded that he furthered himself with evening classes in design. During this period he met his future wife, Margaret, who was the daughter of his employer.

After three years in the jewellery business, he started an apprenticeship with James Buchanan (blacksmith) in Stockwell Street. As this was a stone's throw from the Trongate it is easy to imagine the young Walter passing by the forge and being enthralled by the sight, sounds and smell of hot metal.

Around 1840, and presumably at the end of his seven-year apprenticeship, he moved to Moses, McCulloch & Co.'s Cumberland

Foundry in the Gallowgate. Here he rose
to the position of moulding shop manager
and, in 1848, married Margaret.

Walter was a good friend of Margaret's
brother, Thomas, and in 1851 went
into partnership with him and another
friend, James Marshall. They took over
a disused brass foundry in Saracen Lane
in the Gallowgate. By 1861 they were
employing 120 people.

By this time they had outgrown these
premises and relocated to expanded
premises in Washington Street, in
Anderston. Their premises were designed
by the architect James Boucher, who went
on to form an association with the firm.

However, they weren't here very long,
as a decision was made to move to a
greenfield site. You can imagine from the
firms where Walter worked that central
Glasgow was a hive of industrial activity,
much of it supporting the nearby Clyde.

'Keep the pavement dry'

Washington Street in Anderston was such a place, full of workshops
but also of tenement buildings. The pressure on space must have been
immense and you can possibly imagine the difficulties there may have
been in casting large pieces in such cramped areas.

The final site for the Saracen Foundry was to be in the Grounds of
Possil House, near Maryhill. This was named Possilpark by McFarlane
and in 1872 was established as one of the largest and greatest of
Glasgow's, and Scotland's, industrial sites. I particularly remember the
tower, which was a Glasgow landmark but is now demolished. The new
factory occupied 24 acres and employed 1,200.

The McFarlanes moved into a fine house in the posh Park Circus area
of Glasgow. 22 Park Circus was designed by Boucher. The interior is
testament to some of the finest work produced by the foundry. The house
went on to become an Italian cultural centre and is now a fine location
for Glasgow City Marriage registrations.

During this time, Walter was not forgetting his civic duties. He became
a member of the town council in 1864 as well as joining the Institution

Cast-iron urinal at Ferintosh on The Black Isle. It says 'Please adjust your dress'

of Shipbuilders and Engineers. He was also clearly concerned about waste disposal. In 1857 he read a paper to the Philosophical Society of Edinburgh: 'Sanitary Arrangements for converting the excrementary refuse, dry garbage, ashes etc of towns into their most valuable purpose'.

While Walter McFarlane remained the figurehead of the company, his partners Thomas Russell and James Marshall were intimately involved in the development and running of the business. Each became wealthy men in their own right.

As Walter had no son of his own, on his death in 1885 the company passed to his nephew, also Walter. Walter McFarlane II was left very much to develop the business, Thomas Russell having also died in 1863.

Walter McFarlane Snr was buried in the Necropolis, Glasgow. His monument bears a bronze portrait by the sculptor Bertram MacKennal. On his death, Walter McFarlane was a very wealthy man. His estate records show that he had shares in such diverse interests as Moffat & Kilmacolm Hydros, the Saracen Pottery Company and Lambhill Cemetery Company.

Walter McFarlane and the Saracen Foundry may have gone, but he has left us with solid reminders of Glasgow's style and enterprise throughout the world. In Brazil and Australia, India and at home in Scotland there are lasting reminders of his work. These are seen in staircases, banisters,

Walter McFarlane's grave in the Glasgow
Necropolis

bandstands, fountains and lamp standards, all illuminating the skill of
the Glasgow iron worker.

The foundry continued in operation into the early twentieth century,
but eventually saw a decline in the industry and demand for such
ornamental cast ironwork. Much of the product of the foundry was
going overseas. But the days of empire were drawing to a close. In the
colonies, foundries were being established and Scottish iron was not
needed. Although there was still a call for some standard traditional
products such as the classic red telephone box, tastes were changing and
new materials were being developed. Iron was being replaced by steel.
Electricity was replacing gas. Ceramic was replacing cast-iron plumbing.

The company became part of Allied Ironfounders in 1965 and was
absorbed into Glynwed in 1966. The foundry at Possilpark eventually
closed and was demolished in 1967. The company name was bought
by Glasgow firm Heritage Engineering in 1993. With an extensive
archive, this company specialises in the conservation and restoration
of architectural ironwork and continues to manufacture many of the
original designs of the Saracen Foundry.

Matt McGinn
Singer and Comedian

Another of my heroes is Matt McGinn, who had a similar background to, and whom I think knew, my father. Both of them came from the East End and went on to become secondary teachers as a second career.

Matt was one of a family of nine: five sisters and three brothers. He was born in Ross Street, one of the streets making up the Barras area. He was forty-nine when he died an accidental death at home in 1977.

Matt was 12 when he left school, due to the fact that the wee rascal was sent to St Mary's Remand Home. But like many others from the East End, it didn't stop him being well-read during his years working at Guest, Keen and Nettlefold in Hillington. At thirty-one and being a Union man, he won a Trades Union scholarship to Ruskin College in Oxford.

He received a diploma in Economics and Political Science and was accepted to Huddersfield Teacher Training College. Matt returned to his new home in Rutherglen, where he taught in a number of schools.

Matt McGinn 1928–1977

Matt's output was prolific. In looking back at his songs and poems I was reminded that had he written 'The Ballad of John MacLean', 'If it wisnae for the Union' and '3 nights and a Sunday Double Time', all of which endeared him to the Glasgow working classes. Most Glaswegians will also remember 'The Wee Red Yo-Yo' with great fondness. If you ignore the support of belting in the classroom as being a product of the time, 'Rap Tap Tap (upon your fingers)' is a great wee song. And one of my favourites for humour is 'The Big Effen Bee'.

The Big Effen Bee

He kept bees in the old town of Effen
An Effen beekeeper was he
And one day this Effen beekeeper
Was stung by a big Effen bee

Now this big Effen beekeeper's wee Effen wife
For the big Effen polis she ran
For there's nobody can sort out a big Effen bee
Like a big Effen polisman can

The big Effen polisman, he did his nut
And he ran down the main Effen street
In his hand was a big Effen baton
He had big Effen boots on his feet

The polis got hold of this big Effen bee
And he twisted the Effen bee's wings
But this big Effen bee got his own back
For this big Effen bee had two stings

Now they're both in the Effen museum
Where the Effen folk often come see
The remains of the big Effen polis
Stung to death by the big Effen bee

That's the end of that wee Effen story
'Tis an innocent wee Effen tale
But if you ever tell it in Effen
You'll end up in the old Effen jail

There was no-one more surprised at his success than Matt himself. He had befriended the great folk and protest singer Pete Seeger during Pete's 1965 tour of Britain, during which he played at the old St Andrews Halls. As a result, Matt found himself being taken to New York to play the Carnegie Hall. As he said, 'from then on everything had to be downhill. Other people had struggled for years towards such an objective and here was I booked for the world's most celebrated concert hall'.

Jim Friel tells a story about the Bothy Bar in the Bath Hotel in Bath Street. A scruffy wee man with a bunnet was sitting in the corner of the bar drinking a pint. When he was asked by a member of staff if he was going into hear the singer, he asked how much it was. He was told that it was five shillings. 'Five bob to hear me!' he replied in astonishment.

He died on 6 January 1977, and some of his ashes were scattered on the grave of the great John McLean in Eastwood cemetery.

But before we leave Matt we should also say a word about Janette McGinn, who supported Matt through all of the ups and downs of his career. She was a fighter for social justice who is remembered as having a prominent place in protests against the Poll Tax and the resultant evictions, herself refusing to pay. She was due to be the first person in Britain to suffer a 'poinding', being evicted with her possessions dumped on the doorstep. She phoned the Anti-poll Tax Federation, who turned up in busloads to support her. The sheriff's officers backed down and didn't appear. Janette was also present at the 'Battle of Turnbull Street' where 500 protesters prevented a warrant sale from taking place. A worthy lady.

Lex McLean

Entertainer

Lex was actually a Bankie Boy but had no hesitation in calling himself a Glaswegian. Glaswegians responded by taking him to their hearts and loving his humour. It was risqué but never smutty. The whole family could go and see 'Sexy Lexy'.

> I spent six years in my first school – the happiest
> days of my life. Then they took me out of there and put me
> in a boy's school. It was a school for backward boys.
> However I didn't mind in the least for just across
> the road was a school for forward girls!

Alexander McLean Cameron is acknowledged as the last great Scottish music hall act and was a huge draw at the Pavilion and many other theatres from the 1950s until the 1970s.

When he left school he was an apprentice at John Brown's shipyard for a short time but he seemed to have his heart set on a musical career. From his early days in Clydebank, it was clear that Lex was destined for the stage. His first 'gig' was playing the piano in the Clydebank Pavilion in Kilbowie Road. He was grateful to his straight-laced mother for scrimping to buy his first accordion and making him practice. However, she thought that being a comedian was a low occupation and refused to acknowledge his choice of career. She never went to see him and when asked about him, would say that he was 'travelling'.

Lex's first foray into the entertainment world was a short-lived season with the Girvan Entertainers, where he is seen in Bertie Wooster '20s garb in a banjo troupe. He moved to Belfast where he tried street

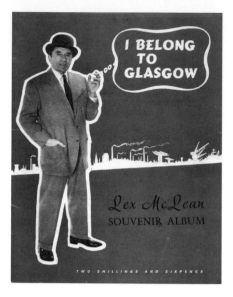

'Keep it bright!'

entertaining before returning to Scotland and joining the 'Imperial Scots' tartan troupe. After a year he took the ambitious step of forming his own concert party, 'The Meltonians', and toured Scotland for four years.

During the Second World War, Lex's comedy career was not interrupted as he had an involvement in the first Entertainments National Service Association (ENSA) company, visiting army units throughout Scotland.

Following the war, Lex got a break in Glasgow Empress Theatre and got on famously with the tough Glasgow audience. When Tommy Morgan retired Lex was offered a summer season at the Glasgow Pavilion. From this start, Lex went on to become a legend. While working throughout Scotland, he made the Palladium his home. His team included Jimmie and Vonnie Carr, whom he enticed from George Formby; Ronnie Dale, another great Glasgow musician and comedian and Jinty McEwen, a dancer 'who has been with me since Rangers had a good forward line'. He also worked with 'Mr Glasgow', Glen Daly. On his show he presented other entertainers who went on to success. These included Andy Stewart, The Alexander Brothers and The Harmonichords, a fresh faced group of Irish boys who went out to carve out success as The Bachelors with hits such as 'Charmaine' and 'Diane'.

In the 1960s he was given his own shows on the BBC, where he appeared with straight man Walter Carr as 'Shooey', this taking him into every Scots living room in 'Lex' and 'Lex Again'. He was an avid Rangers

fan and even had Ibrox Legend George Young guest on his show. The great Larry Marshall of *One O'Clock* fame also put in an appearance.

It was on a summer season in Burntisland that Lex met his wife Grace. There is a photograph of them in 'Gilroy's Entertainers'.

We got married to keep the neighbours from talking.
That's me in the white tie. Grace is on the right –
She's been right ever since.

Grace Dryburgh had been a dancer who had formed her own troupe, 'The Dryburgh Girls'. She gave this up to support Lex when he became resident at the Pavilion. When Lex took ill during an Edinburgh show in 1971, she nursed him until his death in 1975. He called her his 'Amazing Grace'.

Lex is fondly remembered in the Scottish Music Hall website, where his comedy lives on. He was a gentleman.

In a two shillings and sixpence souvenir album he wrote:

Dear patron,
My sincere thanks for your patronage. I hope you
have enjoyed the show and trust that you have found
pleasant reading in the brochure with some items of
interest, with photographs amusing and nostalgic.
I find the great joys in this life are the wonderful memories
of the past and all of us who have them let's be truly grateful.

Sincerely Yours,
Alexander McLean Cameron
for short

Lex McLean

You can read more about Lex on the Scottish Music Hall Society website.

Sergeant John Meikle MM
Nitshill's Victoria Cross

I would like to think that this book is not only about the good and the great. In this instance, I have included a young and a very brave lad from Nitshill and I suppose it will apologize to him for the way in which his memorial was moved from Nitshill Station to outside the station at Dingwall in Ross-Shire.

I spent a lot of my youth at my auntie's in Nitshill and when I moved to Dingwall in the 1980s, it would be natural that I would notice the connection between this station and Nitshill.

John Meikle was a young sergeant in the 4th Seaforth Highlanders during the First World War. Dingwall has long been associated with the Seaforth Highlanders, one of its predecessors being the Ross-Shire Buffs.

On 20 July 1918, near Marfaux in the Ardre Valley, France, the Allies were attempting to push the Germans back over the River Marne. John, armed only with a revolver, single-handedly put out of action a machine gun that was holding up the advance of his company. His revolver being emptied, he continued his attack with a stout stick. Seizing the rifle and bayonet of a fallen comrade, he then charged another machine-gun post. He was killed as he was doing so but his bravery allowed the position to be taken by two fellow soldiers.

John was born in Kirkintilloch in 1898. On leaving school he joined the Railway Company and worked as a clerk at Nitshill Station. He was apparently an avid football fan and a follower of Nitshill Royal Victoria. He 'answered the Call' on 8 February 1915. Although he was still only sixteen he gave his age as eighteen. The monument was erected by his railway colleagues, but due to vandalism it was removed to Dingwall, where it now stands proudly behind the replica of a makeshift

monument originally erected at the Battle of Cambrai in 1917. The Seaforth Territorials distinguished themselves in this action.

John is buried in the British Military Cemetery at Marfaux.

Dingwall Museum has a very nice display about John, including his Victoria Cross. It is well worth a visit. It also has a display on the life of Major-General Hector MacDonald, the Boer War hero who appears on the front of Paterson's Camp Coffee bottles.

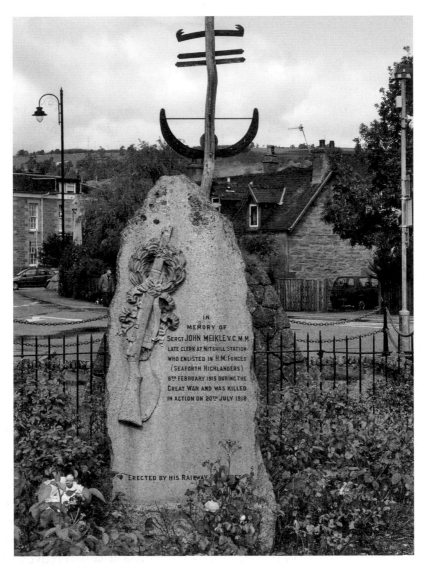

Memorial to John Meikle VC, Station Square, Dingwall

William Miller

Poet of the Nursery

Willie Winkie

Wee Willie Winkie rins through the toon,
Up stairs an' doon stairs in his nicht-gown,
Tirlin' at the window, crying at the lock,
'Are the weans in their bed, for it's now ten o'clock?'

'Hey, Willie Winkie, are ye comin' ben?
The cat's singin' grey thrums to the sleepin' hen,
The dog's speldert on the floor, and disna gie a cheep,
But here's a waukrife laddie that wunna fa' asleep!'

Onything but sleep, you rogue, glow'ring like the mune,
Rattlin' in an airn jug wi' an airn spoon,
Rumblin', tumblin' roon about, crawin' like a cock,
Skirlin' like a kenna-what, waukenin' sleepin' fock.

'Hey, Willie Winkie - the wean's in a creel!
Wambling aff a bodie's knee like a verra eel,
Ruggin' at the cat's lug, and ravelin' a' her thrums
Hey, Willie Winkie – see there he comes!'

Wearit is the mither that has a stoorie wean,
A wee, stumple, stousie, that canna rin his lane,
That has a battle aye wi' sleep afore he'll close an e'e
But a kiss frae aff his rosy lips, gies strength anew to me.

Perhaps not in this form, but there are few in Scotland and beyond who have not been put to bed with this famous rhyme. I certainly was, and it was a surprise and a delight to learn that the author of 'Wee Willie Winkie' came from Dennistoun. There is a plaque on the wall of Tennent's Wellpark Brewery marking the site of where his house stood.

William wrote other children's verse and has been given the name of 'Laureate of the Nursery'. 'Wee Willie Winkie' is known round the world, although not in its original version as it was written in the Scots dialect of the time. And we all want our children to be in bed a little before ten o'clock!

Born in 1810, he lived at Ark Lane in Glasgow's Dennistoun area. He had aspirations to be a surgeon but persistent ill health appears to have prevented this. He became apprenticed as a wood turner and progressed onto cabinet

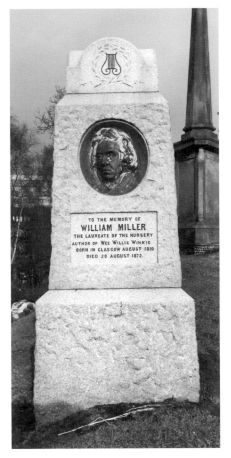

Memorial to William Miller, Glasgow Necropolis

making, on which he spent his life. He retired in 1871 due to ill health, at which time he was penniless. He seems to have made no money out of either cabinetmaking or poetry. He died in 1872 in Winsor Street and was buried in Tolcross Cemetery. A monument to his life and work, paid for by public subscription, was erected in Glasgow's Necropolis.

Miller started writing poetry and songs when he was young and these were published in magazines and collections of songs. 'Wee Willie Winkie' appeared in an 1842 book called *Whistle-Binkie or The Piper of the Party – Being a collection of Songs for the Social Circle*, published by David Robertson and printed by Neilson in Paisley. This book is out of copyright and can be found by a web search. It is well worth the effort as it also contains works by contemporaries of Miller.

In the same edition of *Whistle-Binkie* appears 'John Frost', a comment on an early white winter.

John Frost

You've come early to see us this year, John Frost,
Wi' your crispin an' poutherin' gear, John Frost;
For hedge tower an' tree, as far as I see,
Are as white as the bloom o' the pear, John Frost.

You've been very preceese wi' your wark John Frost,
Altho' ye hae wrought in the dark, John Frost;
For ilka fit-strap frae the door tae the slap,
Is as braw as a new linen sark, John Frost.

Now your breath wad be greatly improven, John Frost,
By a whilock in some bakers oven, John Frost;
Wi het scones for a lunch, an a horn o' rum punch,
Or wi' gude whisky toddy a' stovin, John Frost

In the fourth series of *Whistle-Binkie* appears 'The Sleepy Laddie'. Here are the first and last verses. It seems that Wee Willie Winkie cannae get up in the morning!

The Sleepy Laddie

Are ye no gaun to wauken the day, ye rogue?
Your parritch is ready and cule in the cog,
Auld baudrons sae gaucy, and Tam o' that ilk,
Wad fain hae a drap o' the wee laddies milk.

So get up to your parritch! and on wi your claes!
There's a fire on might warm the cauld Norlan braes!
For a parritch cog, and a clean hearth-stane
Are saut and sucker in our town-en'.

These two songs are equal to many songs written by Burns. While his output was not as prodigious as Burns, perhaps what he has produced is worthy of more attention?

CHUCKIE.

SAW ye chuckie wi' her chickies,
Scraping for them dainty pickies,
Keeking here and keeking there,
Wi' a mother's anxious care,
For a pick to fill their gebbies,
Or a drap to weet their nebbics?
Heard ye weans cry " teuckie, teuckie!
Here's some moolins, bonnie chuckie?"

When her chickens a' are feather'd,
And the school weans round her gather'd,
Gi'en each the prettiest name,
That their guileless tongues can frame;
Chuckie then will bend her neck!
Scrape wi' pride, and boo and beck!
Cluckin' as they'er crying " teuckie!
Here's some moolins, bonnie chuckie!"

From *Whistle-Binkie – A Selection of Songs for the Social Circle*
A Whistle-Binkie, by the way, is a musician or storyteller who
played at penny weddings and gatherings and who was dependent
on the audience for payment. A penny wedding is one at which
the guests bring their own food and drink. Sir Walter Scott makes
reference to it in Heart of Midlothian; 'Doctor, my breath is
growing as scant as a broken-winded piper's, when he has played
for four-and-twenty hours at a penny wedding'.

James R. Napier

Marine Engineer and Coffee Machine Inventor

On re-reading Arnold Fleming's wonderful *Scottish and Jacobite Glass*, I saw that it mentioned that James Couper & Sons had produced globes for the 'Napierian' coffee machine. I was intrigued by this and my research found that what we now know as the 'Cona' coffee machine was actually invented around 1840 by a Glasgow marine engineer, James R. Napier. Sadly for him and his family, he never patented it.

It was demonstrated by David Thomson, Tea and Coffee Merchant, of Renfield Street to the Institution of Mechanical Engineers in the Gallery of Art in 1866.

The instructions show that water and ground coffee are put together into the jar. A small amount of water in the globe is heated by a burner and the steam generated is forced into the jar, mixing the coffee and water. When the heat is taken away, the vacuum created pulls the coffee mixture back into the globe, from which it is served. This type of coffee machine became very popular, with this being a fine example produced with Royal Crown Derby china and presumably James Couper's Napierian globe.

We should also give James R. credit for his engineering prowess. Born at Camlachie, James Napier was son of the Robert Napier of Shandon and, at one time, ran the shipbuilding part of his father's business based in Govan, becoming a full partner. He was instrumental in developing methods of plating ships as an alternative to the traditional 'clinker'-built methods of overlapping iron sheeting, as had been used in wooden vessels.

He was also responsible for a range of innovations for boilers, and for ship design, including a new type of shallow draft gunboat for river work in India.

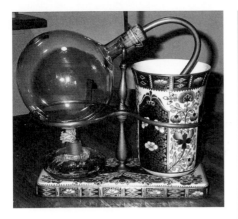

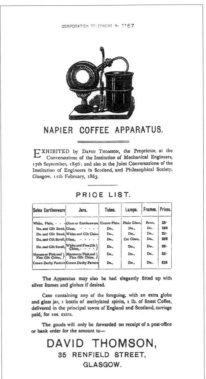

Top left: The Napierian Coffee Machine

Above left: Plate presented to David Thomson for explaining the Napierian Coffee Machine

Above right: Advert for the Napierian Coffee Machine

One of the newfound problems confronting iron ships was the deviation experienced with the compass. It is clear that James was an inventive sort of a chap with a love of mathematics. He put his mind to this problem and along with chum, Archibald Smith of Jordanhill, he came up with a graphic method of correcting deviations in a ship's compass. These 'Napier's Diagrams' are quite famous in shipping history.

James R. Napier clearly had a flourish and was an inventive genius. He continued to contribute to ship design and experimentation even until his death, which was occasioned by a chill caught in Loch Lomond while carrying out such experiments.

Sir Hugh S. Roberton

Conductor of the Glasgow Orpheus Choir

What care we tho' white the Minch is
What care we for wind and weather?
Let her go boys, every inch is
Wearing homeward to Mingulay!

His choir certainly thought that Hugh had a flourish and they loved him so much that they disbanded on his death!

The Glasgow Orpheus Choir had its roots in 1901 in the Toynbee House Choir in the Toynbee Men's Social Club at 25 Rottenrow. With seventeen-year-old Hugh Roberton as conductor, two hard years' work culminated in a concert at the East End Industrial Exhibition in 1903. There was a bit of a falling out and the choir left the club in 1906. With Hugh on the podium, the Glasgow Orpheus Choir played to a packed St Andrew's Hall in Glasgow, followed by London's Queen's Hall in 1908. A tour followed, which included Leeds, Liverpool, Birmingham, Sheffield, York, Manchester and Dublin.

This was followed in 1926 by a highly successful tour of Canada and the United States in which they gave twenty-two concerts in twenty-six days. They gave over 1,000 concerts in forty years.

Sir Hugh was born in 1874 in Tradeston. His family were funeral undertakers and carriage hirers. Hugh worked in the family business.

Besides being in at the start of the Orpheus, he was a composer and wrote 'All in the April Evening', a beautiful choral work. He put the words to 'Westering Home' and 'The Mingulay Boat Song' and translated 'Marie's Wedding' from the original Gaelic.

Hugh had joined the Independent Labour Party in 1914 and his

Buchanan Street,
Glasgow, 1901.
Year of the Glasgow
International
Exhibition and
start of the Toynbee
House Choir

close friend was Ramsay MacDonald. Hugh was a member of the Peace Pledge Union, a pacifist organisation, and this caused the choir to be banned from broadcasting during the Second World War. He had received a knighthood in 1931, regarding it as recognition for the Glasgow Orpheus.

Sir Hugh retired through ill health in 1951 and died at his home in Cathcart in October 1952. So much did they love Sir Hugh and consider the choir to be his that the Choir decided to disband. Some of the choir members then formed the Glasgow Phoenix Choir, which is still going strong.

Hugh Roberton:

Without Glasgow behind us there would never have been any worthwhile story to write. When we say Glasgow, we do not mean all Glasgow, for there are chunks of Glasgow completely oblivious of our work. But in Glasgow we have always had our people. Through good and ill report they have stuck by us. Never have we called on them in vain. Not that we have asked very much of them, nothing more than their support. But that has been given with a warmth and an emphasis which to us is one of the most moving things in all our story. Glasgow people have enabled us to fare forth. In effect, what the Glasgow support has meant to us, and still means to us is this – 'Go ahead! We are behind you.' Well, it is up to us to be worthy of that.

John Scott Russell

Marine Engineer

John Scott Russell was the man who discovered the Soliton. No, it's not science fiction, but a very specific kind of wave. He also built the *Great Eastern* with Brunel and designed the famous HMS *Warrior*. He built the huge dome of the Vienna Exposition in 1873. If that is not enough to get you in this book, he also started the first steam carriage between Glasgow and Paisley. Unfortunately it blew up with a bit of a flourish.

Scott Russell was born in 1808 and one of the amazing number of people of that time who contributed to ship design. Inventions and patents just kept coming. And like many others, his major invention was not appreciated till after his death.

Russell was born in Bridgeton to clergyman David Russell and Agnes Clark Scott. A year at St Andrews University was followed by a degree taken at Glasgow University. He graduated at seventeen whereupon he moved to Edinburgh to teach mathematics. At twenty-four he was elected on a temporary basis to fill the place of Sir John Leslie, Professor of Natural History, who had died.

There is a very famous story about the birth of passenger road transport, with one of Russell's vehicles being held responsible for the first fatal bus crash. Russell built vehicles for the Scottish Steam Carriage Company in 1834. They carried twenty-six passengers between Glasgow and Paisley. Unfortunately, the trustees who objected to the new transport were accused of sabotaging it by making a road block which overturned the carriage. The boiler blew up, killing four passengers. The service was discontinued but two of the carriages moved to London to operate.

He then moved on to design boats for the Union Canal Company. The canals had had their 'golden years' but were now beginning to face

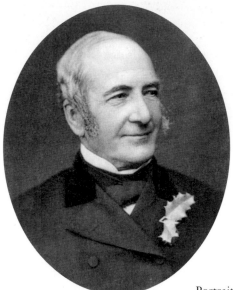

Portrait of John Scott Russell

competition from the railways, and from steam carriages. It was during this period that he made his famous discovery.

His discovery of the 'wave of translation' was in 1834, when he was watching a horse pulling a barge on the Union Canal near Edinburgh. He was investigating the most efficient design of canal boats and discovered that the bow wave formed was slowing the boats. When the boat halted, he noticed that this bow wave produced by the boat continued in one wave 'without change of form or diminution of speed'. He followed it on horseback and overtook it as it was travelling about nine miles an hour. It was thirty feet wide (9 m) and a foot and a half (300–400 mm) in height. 'Its height gradually diminished and after a chase I lost it in the channels.'

Now, on reflection you might have noticed this effect yourselves when rowing your boat up the Clyde. It was up to Scott Russell to see significance in this. So much so that he built a tank in which to pursue experiments. His findings did not seem interesting to many people at the time, but they were to have huge significance in the understanding of waves in other mediums, particularly in the development of fibre optics. It was called a 'Soliton' at a later date.

He worked out the speeds that would maximise the efficiency of canal boats and is credited with introducing, in 1841, a unique night sleeper

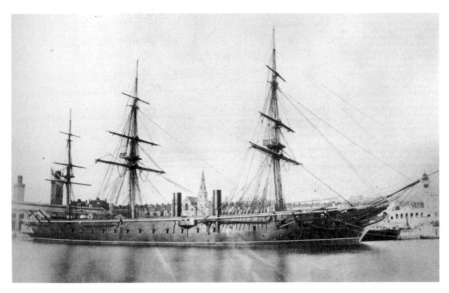

HMS *Warrior c.* 1860

canal service between Edinburgh and Glasgow. Maybe they will bring that back now that the canal has reopened?

This was important enough for John to be immortalised on a new viaduct carrying the Union Canal over the Edinburgh City bypass. This was named in 1995 in the presence of an international gathering of scientists who recreated the Soliton effect.

Perhaps this might all seem a bit academic, but not so his practical contributions to shipbuilding. Most people know that it was Isambard Kingdom Brunel that built the largest ship of its kind at the time, the *Great Eastern*. Well, in fact it was Isambard Kingdom Brunel and John Scott Russell. John had moved to London in 1844 and was the organiser of the Royal Commission for the Exhibition of 1851. He formed a new company, the J. Scott Russell Shipbuilding Company. He built the *Great Eastern* with Isambard Kingdom Brunel. He does not seem to have been a very great businessman, having financial difficulties which delayed the progress on the ship. They fell out over design aspects but the ship was eventually launched in 1858. Brunel's early death has been attributed to the difficulties he had with Russell. Not so good.

Russell's next great project was the building of the famous HMS *Warrior*, the first British iron-clad warship. The building of the *Warrior* was part of an arms race between Great Britain and France. The first

iron-clad warship, *La Gloire*, had been launched and this was seen as a threat by Sir John Somerset Pakington, First Lord of the Admiralty. He wanted a response to this and commissioned HMS *Warrior*, which was intended to be superior in size, armament and armour to anything France had produced. When launched she was the largest warship afloat, 60 per cent larger than *La Gloire*, and displaced 92,100 tons.

She was initially sent for service to the Channel Squadron in 1862. However, having established her place in naval history, she was quickly superseded by faster ships with heavier armaments. She was downgraded to coastguard services until 1883, when her rotten masts were considered too costly to repair, so she was put into the reserve and she was eventually given the role of a floating navy school with the name of *Vernon III*.

I have an interest in the *Warrior*, having seen her lying in the harbour in Hartlepool around 1978. I had been living there and discovered her in the dock. There was very little to see but it was clearly a huge sailing ship. It had been used as an oiling barge and was basically a flat, black, oily hulk. Someone must have seen something salvageable as it has been brought back to glorious life and sits in Portsmouth Harbour.

Much later, Russell was contracted to build the huge Rotunda at the Vienna Exposition of 1873. This was seen as a huge feat of engineering and design. Russell used 4,000 tons of iron for the building. The dome was huge at 440 feet diameter and 284 feet high. The dome was 3.17 times larger than the dome of St Paul's. It was the largest dome in the world at the time.

To round this all off, he also advocated vocational education in his 1869 'Systematic Technical Education for the English People'. This is a detailed comparative study of vocational education in other countries and recommendations for technical curricula.

He also wrote the *Modern System of Naval Architecture* and founded the Institute of Naval Architects. He is remembered for a particular sort of linkage, the 'Scott-Russell', which is used in modern motor cars. So, that's a suspension linkage, a canal bridge and a few buildings. Better than a sausage, I would say.

He died at seventy-five in Ventnor on the Isle of Wight in 1882. His business had continued to deteriorate, so he wasn't particularly wealthy when he died. But what a legacy.

Tommy Shields 'Mr 242'
Radio Entrepreneur

As far as I am concerned, you don't actually have to be law-abiding in order to show that you are a Glaswegian with a flourish. And this is true of Tommy Shields, 'Mr 242', who was the guiding light behind the pirate Radio Scotland. And he goes into this book as I was one of those young lads who slipped away from school at lunchtime in order to take requests for records to be played on the new pirate station. Their head office was in Cranworth Street, just off the Byres Road.

The man behind all of this was 'Mr 242' himself, Tommy or T. V. Shields. Tommy had previously been in at the birth of Scottish Television as Press and Publicity Manager, but saw the opportunities afforded by radio and was involved unsuccessfully in trying to establish land-based stations.

An unknown Simon Dee opened Radio Caroline on Easter Sunday 1964, and was then the very first pirate radio ship broadcasting. The monopoly on broadcasting held by Radio Luxembourg and the British Broadcasting Corporation had been broken and it was not long afterwards that Tommy took the plunge. Radio Scotland began broadcasting on Hogmanay 1965.

> Radio Scotland
> Playing just for you
> So beat the ban
> And join the clan
> On good old 242

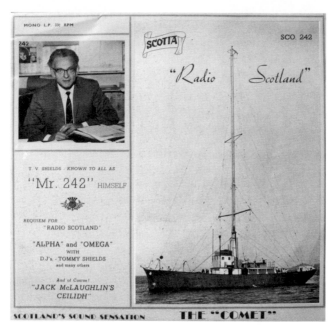

Requiem for Radio Scotland

Radio Scotland was a phenomenon and extremely popular. Jack McLaughlin's *Ceilidh* provided us with a successful mix of traditional and modern as well as the wit from 'The Laird of Cowcaddens'. Contributions from Tony Meehan, Stuart Henry and Richard Park were what youth in Glasgow were waiting for.

Radio Scotland also had a magazine, 242, which I bought regularly. Being a PR man, Tommy knew that marketing would be behind the success of the station. The magazine was popular and besides advertising, it contained reports and photos from Radio Scotland's 'Clan Ball'. It had articles on the stars of the day. Featured in it were the likes of Chris McClure (Christian) and the Section, Lulu and Adam Faith.

Although it quickly became a well-loved institution, it was an irritation to the BBC and the government were forced to do something about it. They could not do anything about the broadcasting as it was outside territorial waters. But they could do something about those trying to reach the boat.

The station closed on 14 August 1967, when the Marine Offences Act came into force. This effectively made it illegal to supply pirate ships from the mainland. This included staff, advertising and pre-recorded tapes. It effectively isolated all offshore operators. While Radio Caroline

Christian on the Dock of a
Bay

struggled on, pirate ships supplied from Great Britain ceased operation. Radio Scotland tried to be exempted on the basis that it reached parts of the country not served by the BBC. It failed.

Here is an album produced as a Requiem for Radio Scotland and features such presenters as Stuart Henry, Tony Meehan, Bob Spencer and Tommy Shields. The album included 'We're no awa tae bide awa' but unfortunately they were.

Radio Scotland broadcast from *The Comet*, which was built at John Brown's as an Irish lightship before it began broadcasting. When the curtains finally came down, it was towed to Methill while a buyer was found. When there were no takers it was towed to Holland for breaking up.

Tommy died not long after Radio Scotland was forced to abandon ship. It is said that he had been broken-hearted at the end of his dream. However, he was part of the pirate radio movement, which was instrumental in forcing the broadcasting authorities to examine their outdated approaches and find out what young people actually wanted. Not long after, the BBC introduced Radio One, as well as *Top of The Pops*.

Tommy's legacy was also a platform for the development of a host of young broadcasters who went on to Scottish and national broadcasting jobs. Among these were:

Stuart Henry courtesy of Jon Myer

Paul Young, who went on to carve out a successful acting career. I saw him first at The Citizen's in Roddy McMillan's *The Bevellers*. He is well known for his fishing series *Hooked on Scotland*.

Richard Park continued in the media, going on to become a judge on *Fame Academy* via Radio Clyde and Radio One. There was also Jimmy Mack, Tony Allan, Tony Meehan and Bob Spencer.

Jack McLaughlin, 'The Laird of Cowcaddens', was another name whose *Ceilidh* was outstanding. Jack continued in broadcasting and hosted STV's *Thingummyjig*, which continued his mix of traditional Scottish and modern.

Many of these broadcasters have contributed to the Glasgow-based Radio Six International. It is well worth a listen on www.radiosix.com.

I particularly remember Stuart Henry. Stuart was a mainstay of the new station. His catchphrase was 'Alright my friends'.

Following his pirate radio career, Stuart joined the new Radio One at its launch and eventually moved to Radio Luxembourg. Unfortunately he developed Multiple Sclerosis and died in 1995. He is well remembered in the Radio Academy Hall of Fame and for his work on behalf of MS research. It all fair takes you back, my friends.

William 'Crimea' Simpson
Lithographer and War Correspondent

If Crimea Simpson was here today, he could use a USA car sticker. He 'Used to Stay in Anderston', where I was brought up, although he was a bit earlier than me, I would admit. Simpson was the earliest war artist and the Mitchell Library in Glasgow has a collection of 600 of his drawings and paintings covering numerous campaigns, events such as the opening of the Suez Canal and the great Vatican Council of 1869, as well as scenes of Victorian Britain.

But that was only part of it. With very little in the way of an educational start he was to become not only a respected lithographer and artist, but a war and foreign correspondent as well as a writer and diarist.[14]

Lithography is a method of printing, using a stone drawn on with wax, such as a crayon. The stone is then treated with water. The stone absorbs the water where it does not have a wax covering. The stone is then inked, with the waxy parts of the stone picking up the ink. The wet bits do not. Paper is then applied to the printing stone and the drawing then transfers to the paper.

When researching Carrick Street, where he lived, I was delighted to find a photograph of a playpark that I visited occasionally as a child on my traipses round Anderston. Even at that time in the 1950s it was still a mixed residential and industrial area.

[14] Simpson's equivalent today would be a top-level war correspondent and reporter. The British public was desperate for news from the wars as well as of royalty and events. Lithography was the only way before the emergence of photography to record events as they happened. The image overleaf would have been the equivalent of front-page news as it shows Florence Nightingale in discussion 'on a quiet day'.

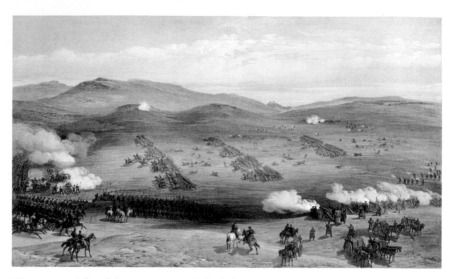

'Cannon to right of them, cannon to left of them, cannon in front of them, volley'd and thunder'd' – *The Charge of The Light Brigade* – Tennyson

Reading recent reports of William Simpson, it would seem as if his family was poverty-stricken. In fact, there is no evidence to support William being in any more parlous state than many others round about him. Glasgow at the time of William's birth had experienced a huge explosion in population, from 32,000 in 1750 to 150,000, much of it through the influx from Ireland and the West Highlands of Scotland.

Carrick Street, over time, was to become like many other streets in Anderson: taken over by all manner of industry. Records show that there were electric engineers and lamp makers, a guano warehouse, steeplejacks, seedsmen and scrap merchants. When William was born it would be at the start of this industrial period, living in a small two- or three-floor typical Glasgow stone building before the tenements and warehouses were hastily erected round about the factory.

An 1865 photograph by Thomas Annan shows that besides the factories and tenements going up, there were considerable numbers of old Glasgow town houses and merchants' buildings. These were the buildings that were to become the first slums as they were converted to accommodate huge numbers of dwellers without adequate services to match. Bear in mind that few people saw anything wrong in this mixed way of living. Neither did we in Anderson well into the 1960s.

His autobiography, written in 1903, says that his father was well-

connected, knowing Tod and MacGregor, the famous shipbuilders, as well as Alexander Campbell of the Orbiston Cooperative, based on the system put in place by Robert Owen at New Lanark. Apparently William's family became involved in this cooperative venture, but it failed. They returned to Glasgow, to a tenement in North Frederick Street at the corner of Little Hamilton Street. His mother was Ann (née Johnstone).

He tells how he was sent to Perth for fifteen months to stay with his Highland grandmother whose parents had had to leave the Kyles of Bute as they had lost their property having been on Charlie's side in the '45. It was in Perth that William received his only structured education to date, at the 'Perth writing school'. He returned to Glasgow in 1835.

In 1837, aged fourteen, through a connection of his mother's, he was introduced to David McFarlane, who was looking for a boy to help in his print works at 14 Queen Street. Although he wanted to go into engineering, this started him on the way to fame as a lithographer. He was not here long though and, encouraged through his progress, he managed to obtain an apprenticeship with Allan & Ferguson.

During this time he was keen to develop himself and attended both the Mechanics' Institute[15] and the Anderstonian University, where he attended classes delivered by Thomas Graham. He also attended the new Glasgow School of Design when it opened in 1845 for a good number of years.

After serving four years with Allan & Ferguson, he was encouraged by Mr Allan to try his luck in London. Without any difficulty he obtained, in 1851, a place with Day & Sons, a prominent company in the field. It is quite clear that these successive companies could see how good he was, although he does not boast about this in his autobiography.

[15] Glasgow had the first Mechanics' institute, which was started in 1823. Mechanics' institutes were to open throughout the world and were the forerunner to further education colleges. The institute in Glasgow was based on foundations laid down by George Birkbeck. Mechanics courses were offered in science, mathematics, architecture, naval architecture, engineering, engineering and architectural drawing.

The industrial revolution created a need for primarily young men to learn more than just the practical aspects of their trades. The Mechanics' institutes provided lectures by well-known experts in their fields. They were also a place where these young students could 'network' with like-minded learners who would generally attend in the evenings after their day's work was done.

In Scotland, a general education was always seen as important, so it would be no surprise that as well as leading the world in engineering, it would also lead the way in technical education. In 1887, the institution merged with Anderson's College, Alan Glen's Institution and others to form the Glasgow and West of Scotland Technical College. This became the Royal College of Science and Technology, which in turn became Strathclyde University. Birkbeck moved to London and established the London Mechanics' Institute, which later became Birkbeck College.

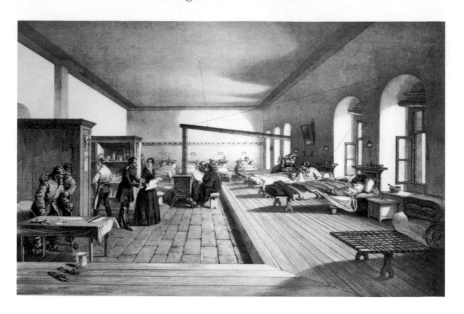

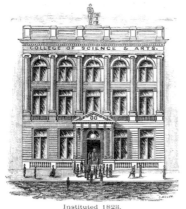

Above: Hospital at Scutari, Crimea

Left: Glasgow Mechanics' Institute, Bath Street

1. Name – This Institution will be unalterably called The Glasgow Mechanics" Institution for the Promotion of the Arts and Sciences.

2. Property – The property in this Institution will consist in a hall, library-rooms, workshop, and other suitable apartments; with books, models, apparatus, natural curiosities, and every other things necessary for the furtherance of the objects of the institution.

From the Constitution, Feb 1824

He got his 'big break' when he was asked to travel to the Crimea and draw the fall of Sebastopol. Until then, while he was producing watercolours, his job was mainly the transfer of drawings by other artists onto printing plates. The combination of the jobs of drawing and etching gave him the opportunity of travelling as a 'special artist', covering wars and events throughout Europe and the East. These included the Franco–Prussian war and the Afghan war. He became the favourite watercolour artist of Queen Victoria and was a frequent visitor to Balmoral and Windsor.

During his time in the East he became interested in both culture and religion and would be photographed in native costume. Because of this, he became thought of as a bit of a nutter. He produced works on such diverse subjects as Buddhist prayer wheels.

He married Maria Elizabeth Burt late in life and had one daughter, Ann Penelope. His autobiography tells that this delay in marrying was because of having to support his father, who seems to have become a drain on him. He had moved his parents to London, where his mother died in 1854. One of William's last projects was recording the opening of the Forth Bridge, during which he had to stand for long periods of time in the snow. He caught a chill from which he never fully recovered. He died in 1899 and is buried in Highgate Cemetery, near to the grave of Karl Marx.

He never forgot his youth in Glasgow for, in his autobiography, he describes the games that they used to play in the street. I like to think that he was playing in the same street as I did as a boy, and the games were not so very different either.

Robert Stewart

Glasgow Lord Provost

When I was a boy in Anderston in the early 1960s, it was a bustling commercial and residential area of the city. Around Anderston there were 'brokies', or bits of land, big and small, whole blocks sometimes. These were the results of bombing raids during the Second World War, or of areas that had been demolished and not built on.

These and the backyards were our playgrounds. To one of these, all of the children in the area were summoned one day by whistles and shouts. In clearing away concrete, a mechanical digger had uncovered an old well. With the different approaches at that time to health and safety, two dozen young people of varying ages crushed round the gaping hole, which was about six feet wide. A few of us threw stones down without hearing a splash or the sound of them hitting the bottom. We thought it was bottomless but obviously not, as it was filled in the next day. This had been a great event even in the busy timetable of a young Glasgow lad in the summer holidays. Progress could not stop for the well was in the way of the preparations for the approaches to the Kingston Bridge, across which would be carried the new M8 motorway.

It was quite an event, for where else would city boys have seen a well except in storybooks? For in the 1950s every schoolgirl and boy knew that our drinking water came from Loch Katrine by way of the Mugdoch Reservoir at Milngavie.

Looking down that well gave us an inkling of how Glaswegians at one time would have obtained their water. For Glasgow in 1800, the source of water was the Clyde, the Molendinar and Camlachie burns or a small number of private and public wells. As the city expanded dramatically,

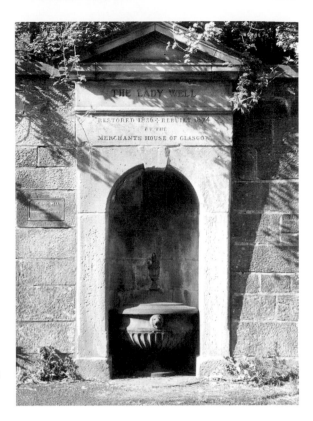

Glasgow's last public well;
the Lady Well off Duke
Street

these wells became polluted and with the slow speed of extraction by
bucket, long queues formed.

The first known solution to the problem was the work of William
Harley, a private individual and entrepreneur who built a reservoir at
the top of West Nile Street, collecting water from springs on Blythswood
Hill. His water carts travelled throughout the city providing stoups
(pails) of water at one halfpenny. Hardy is also supposed to have given
the name to Bath Street, as this was where he had a small swimming
pool and hot and cold baths.

However, this was never going to be enough and the city magistrates
took action. The Glasgow Water Company's Act provided for the
extraction of water from the Clyde to reservoirs at Dalmarnock, which
was then piped to Sydney Street for distribution. Consultants to this
project were the great James Watt and Thomas Telford.

A second bill was enacted in 1808, allowing the Cranstonhill Company
to pump water from the west of the city from Anderston Quay. These

two companies competed until, in 1838, an Act of Parliament allowed the amalgamation of their two companies at Dalmarnock.

This also provided for the installation of filter beds and the construction of pumping engines 'Samson' and 'Goliath' to take the water from the river. By the time the Glasgow Corporation took responsibility for the works in 1856, around 12 million gallons of water per day were being taken.

Around the same time, the Gorbals Gravitation Water Company started providing water. As this turned out to be purer than the water on the north side there was a lot of competition, with most water used on the Southside coming from the new company.

By this time, the need for a properly regulated supply was becoming evident. Street wells were polluted from ground water and even though there were filter beds, these could not cope with the muck when the river was low.

There was a short-lived project to enable the taking of water from Loch Lubnaig, but by this time the Corporation had taken the decision to wade into the water supply problem. J. F. Bateman was asked to report on the best supply of water for the city and the Loch Katrine dream was born. At first it failed because of resistance and scaremongering. One eminent chemist said that the effect of soft water on Glasgow's lead pipes would make it dangerous. This was true and eventually led to the entire system being changed, with the removal of both lead pipes and tanks. The Admiralty objected to taking the water, as it would otherwise have flown down the River Teith to the Forth. This would cause problems in navigation for the Royal Navy!

The bill was finally passed in May 1855, the works being completed in 1859 and opened by Queen Victoria. This was a relatively short time for what was then the greatest system of aqueducts since Roman times and one of Scotland's great engineering projects. The new scheme ensured that Glasgow had the cleanest water supply of any city in the world at that time.

Instrumental in pushing through the project was Lord Provost Duncan Stewart. Born in Glasgow in 1810, he was a contemporary of John Blackie, who had also been a Lord Provost and who was responsible for the City Improvement Act of 1866.

Duncan had begun his working time in Govanhill, in a counting house of Mr Dixon, acquiring his knowledge of business and finance. When his father died, Duncan took on his responsibilities as iron and coal

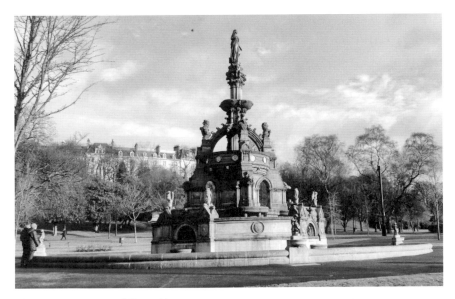

The Stewart Memorial Fountain

master at Omoa on the Cleland estate, property of the Stair family. He was responsible for reconstructing the works, and in addition became involved in mining an extensive field of ironstone. These ventures made him extremely rich.

In 1843, like many of the prosperous men of the day, he took his place in local politics, becoming within one year a river Baillie. In 1845, he became a magistrate and Lord Provost in 1851, to some extent as a reward for his leadership as a magistrate during the civil unrest in 1848 ,in which rioting threatened the population. Duncan Stewart made the supply of water his own and in the face of opposition carried it out steadfastly.

The Stewart Memorial Fountain is a work of art. It commemorates Lord Provost Robert Stewart. It was designed by James Sellars and sculpted by John Mossman. It is topped by the Lady of the Lake, making reference to Sir Walter Scott's famous poem. A plaque is inscribed:

To commemorate the public services of Robert Stewart of Murdostoun Lord Provost of the City of Glasgow from November 1851 till November 1854 and to whose unwearied exertions the citizens are mainly indebted for the abundant water supply from Loch Katrine This fountain was erected 1872.

William Teacher
Grocer and Licensee

There are many Scotch whisky companies that I could use as an example of the enterprising spirit of the Glaswegian. I was brought up in Anderston during the 1950s and 1960s and was surrounded by the bustle of the distilling industry. There were the bonded warehouses of Buchanan's Black & White and that of Arbuckle Smith in Cheapside Street. Those were to go up in flame with tragic loss on the night of 28 March 1960, when a fire started and raged for three days. By the time that fire was extinguished, it had caused the deaths of fourteen firemen and five men of the Glasgow Salvage Corps.

There was also the Clyde Cooperage, supplying the casks to the industry, as well as the stables and drays taking a constant supply of casks to the dock, the goods yards and the pubs throughout the city.

I remember Wm Teachers particularly well as I would be sent to their public house across the road, where there was an 'off-licence'. There were two peculiarities about Wm Teacher's whisky. As far as I know it was the only whisky company that had a chain of eighteen 'tied' public houses, which he called 'Dram shops'. This became very common with brewers but not so with distillers. The other peculiarity was why I was sent to the pub. It sold their own brand of malt vinegar in just the same shape and size of bottle as their whisky.

Wm Teacher, who lived between 1811 and 1876, worked in a grocer's shop in Anderston, where Thomas Lipton was later to open his first shop. In 1834, he married into the family and began to expand the business into wine and spirits shops. His 'dram shops' were said to be run tightly, with anyone overdoing it being ejected. I don't particularly remember that happening to me but I do remember Teacher's bars being extremely

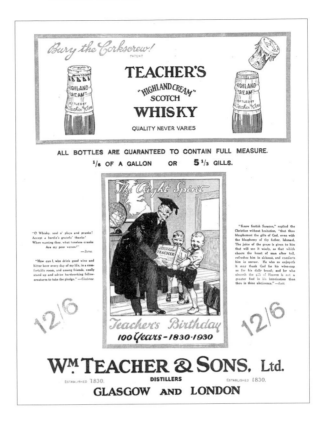

Twelve and a tanner a
bottle

clean, as many others were too. And he was also very far ahead of his
time as he barred smoking in his public houses, as well as discouraging
rounds and loud talk. Apparently he also thought that Glasgow wives
would prefer their men to go to reputable establishments where they
wouldn't come home stinking of drink and fags. Nice idea. It's finally
taking effect.

Teachers eventually became involved in blending and bottling their
own whisky, Highland Cream, which was and is still very popular today.
They built the Ardmore distillery in 1898. (William and Adam Teacher)
Ardmore is still in operation, operated by Fortune Brands, and still
supplying the malt whisky 'fillings' for Teacher's Highland Cream. One
very creative thing that was done was the maturation of whisky in oak
casks on the way to Australia. This saved warehousing costs.

As a footnote, you will see the addition to the Teacher's wrapping
paper here. The addition of 12/6 is probably made in 1920, as on 19
April the price of whisky was put up from ten shillings and sixpence to

twelve shillings and sixpence. It caused uproar and this song was written by and sung by Will Fyffe. It was also sung to me by my father:

Twelve and a Tanner a Bottle

It's twelve and a tanner a bottle
That's what it's costin' today
Twelve and a tanner a bottle
Man it tak's a' your pleasure away

Afore ye can hae a wee drappie
You have to spend a' that you've got
How can a fella be happy
When happiness costs such a lot

It's really high time something is done
To alter the way the country is run
They're no daein' things the way that they should
Just take for instance the price of the food
There's taxes on this, taxes on that
While the people grow lean, the officials grow fat
You have to admit it's a bit underhand
Puttin' a tax on the breath of the land

I used to meet old pals o' mine
When whisky was cheap, went doon like wine
Noo I don't see them I'm sorry to tell
I slip roon' the corner and drink by masel'

This wrapper also says 'Bury the Corkscrew'. This is because WM Teachers used the first ever replaceable cork. This was invented by the nephew of Adam Teacher, William Manera Bergius. It wasn't till 1926 that the screwcap was introduced by White Horse Distillers. Some flourishes.

Of course, it wasn't the first time that the increase in the price of whisky caused uproar. 'The Ferintosh' could have been one of the most famous whisky names in the world had it not been for changes in the tax system. I was very interested in the history of Ferintosh as we built a house there and lived in it for over twenty years. What I discovered was

Original Ferintosh Old Scotch label

that during the eighteenth century, whisky was often called 'Ferintosh' throughout Scotland. This was because for almost ninety years, Duncan Forbes of Culloden was granted the privilege of distilling whisky free of duty. This 'Ferintosh Privilege' started in 1695 as the result of a claim by Duncan Forbes of Culloden for damages to his estates amounting to £4,500 sterling. Apparently, the dastardly Jacobites had ransacked his estates, including his 'brewery of aqua vitae'. This privilege went on until 1784, when it was withdrawn by the government with £21,500 paid in compensation. Not bad eh?

Many people were not amused at the demise of this cheap whisky, and it prompted Robert Burns to write a protest song which included this:

> Thee Ferintosh! O sadly lost!
> Scotland lament frae coast to coast!
> Now colic-grips an' barkin hoast,
> May kill us a;
> For Loyal Forbes charter'd boast
> Is taen awa!

By the way, while the original Ferintosh Distillery (or distilleries) was based around the Ferintosh area on the Black Isle, a subsequent distillery was based in Dingwall and this area also became known as Ferintosh. The name 'The Old Ferintosh' still belongs to Whyte & Mackay and has been produced in limited quantities.

Being Glaswegian, I would I have though that Ferintosh would very quickly have been converted to: 'Gie's a wee Ferry', or 'Whit aboot a wee Tosh?' I think that would have been better than: nip, dram, nippy sweetie, hawf etc.

William Thomson, Lord Kelvin

Scientist and Inventor

My father was a physics teacher in Glasgow and it was from him that I Iearned so much about both the history of Glasgow and physics. He was the kind of teacher who could make a subject interesting and his knowledge was comprehensive. Perhaps that is why he admired Lord Kelvin, who is generally acknowledged as the father of modern physics. My father's degree certificate refers to 'Natural Philosophy', as physics used to be called. It was Kelvin who turned the very small 'nat phil' department at Glasgow University into a large and effective department teaching physics. It was an educational example to the rest of the world. He was also instrumental in turning inventions into practicalities, taking out about seventy patents.

Born in Belfast, he was to move to Glasgow at an early age when his mathematician father took up a post at Glasgow University. He was well provided for and his father ensured an excellent start to his career with introductions allowing him to study at Peterhouse College, Cambridge, where he excelled in all subjects, including sports. However, his main interests were in physics, particularly in the fields of thermodynamics and electricity.

Besides founding a laboratory at Glasgow University and being the first to teach physics in the lab, he was responsible for a wide range of innovations and inventions:

He invented a tide predictor and, using this, produced a theory of revolution of the Earth's poles, this being confirmed with computers in the 1950s.

His work on the Atlantic cable was momentous. He theorised that the quality of the cable was fundamental to the success of electricity flow.

He successfully designed recording equipment that could be used over the huge lengths of the cables.

He introduced the absolute scale of temperature, now measured in 'Kelvins'.

He was a prodigious researcher and produced around 600 papers.

He successfully introduced a range of nautical instruments, including depth sounders, compasses, sextants and chronometers.

His work has been extremely important to science and to Scotland and reflects why Scotland has been so successful in the application of scientific discovery. He was an entrepreneur who could see practical application in his work, and through this contributed considerably to Britain's ability to defend itself through two wars.[16]

In 1899, William Thomson retired from the university and set up Kelvin & James White, based in Cambridge Street. White was an optical instrument maker who had supplied apparatus to Thomson, as well as assisting his experiments and producing electrometers, balances and other instruments based on Thomson's designs.

A major collaboration was the instrumentation for the first transatlantic telephone cable between Ireland and Newfoundland in 1866. After an abortive attempt in 1865, the *Great Eastern* laid the cable in 1866, incidentally finding the lost 1865 cable and completing it. James White produced efficient depth sounding equipment, which was essential in charting out a safe route for the cable. Thomson was

[16] Lord Kelvin was only one of a number of eminent university scholars who put their academic achievements into practice. Among these was Archibald Barr, who was the professor of Civil Engineering and Mechanics at Glasgow University. He went into business with William Stroud and set up the optical instrument company, Barr & Stroud, where I served my apprenticeship. The company was originally based in Byres Road, where they produced optical rangefinders and other instruments, mainly for military use. In 1904 they built the building at Anniesland where I was based. The company was taken over by Pilkington Glass in 1988 and subsequently by French company Thales Optronics.

Thales continues the promotion of university-based innovation with the Scottish Innovative Technology Competition, open to students and staff of Scottish universities. 650 staff are based at Thales' modern plant at Linthouse. The company is a leader in the production of lasers, which started in 1961. They also continue to produce periscopes.

The first periscopes were produced for the Royal Navy in 1916 and that relationship continues until today. Barr & Stroud periscopes were behind British submarines sinking 500 German U-boats during the Second World War. Since then, they have been innovative in periscope design. These have included the world's first thermal imaging periscope, the first laser rangefinder periscope and the first fully remote periscope. The Barr & Stroud periscope in the photo is out of date given that fully electronic systems allow images to be seen on screen. This one is on board the HMAS *Onslow* berthed at Sydney Maritime Museum. The *Onslow* was built at Scotts on the Clyde and launched in 1967. It is a memorial and tribute to Scottish engineering, as evidenced by the labels on the equipment throughout the boat.

Lord Kelvin Kelvingrove Park. Absolute zero at 0 kelvin = −273.15 degrees Celsius

knighted for this work in 1867 and in 1892 took the name Baron Kelvin of Largs, where he had settled. He then became the first scientist elevated to the Lords.

This company, through various incarnations, including Kelvin, Bottomley and Baird, still exists as Kelvin Hughes. Over the years the company has developed many maritime and engineering innovations. These originally included chronometers, sextants and systems such as ultrasound testing for welds. This has gone on to be developed for medical purposes in gynaecology.

On the other hand, there were things he did not get right. He is reported to have said that X-rays were a hoax and that heavier-than-air flying machines other than balloons were impossible!
He was eighty-three when he died at his home, Netherhall, near Largs but given his standing his remains were interred at Westminster Abbey.

William Thompson had been a religious man who was an elder in his local Church of Scotland. He saw no conflict between his physical world and his religious one. He seems to have been a workaholic and when his first wife died in 1873, he bought the 126-ton yacht *Lalla Rookh*. There is a story that he proposed to his second wife, Fanny Blandy, by signal from his yacht while approaching Madeira.

What has interested me with Kelvin is his enthusiasm for all things in physics. I discovered some time ago that he was instrumental in the

Left: Scotland's first diesel engine

Below: Barr and Stroud periscope on board
the HMAS *Onslow*

building of the first diesel engine in Great Britain, by a Glasgow company. The engine had been invented by German engineer Rudolf Diesel around 1892 and was demonstrated in 1897. The only person who seemed to see the potential for this in Great Britain was Lord Kelvin, who was said to be extremely enthusiastic and 'strongly recommended that Mirrlees, Watson & Co.[17] take up the Diesel engine, which they did. I am glad to say that this very first British diesel is still in existence and on display in the Anson Engine Museum in the Peak District.

[17] Mirrlees, Watson & Co. had its origins in a company started by three McOnie brothers to manufacture sugar cane machinery. J. B. Mirrlees became a partner. Following a number of name changes, the company became Mirrlees, Watson & Yaryan in 1889, at the time they investigated the possibilities of the diesel engine. From that time the company went on to develop more diesel engines, and innovative systems such as fuel injections to allow engines to run mostly on tar.

By this time, a factory had opened in Stockport. The company was taken over by Brush, eventually joining the Hawker Siddeley Group and then, through a number of changes, reverted to Mirrlees Blackstone Limited before becoming part of MAN Diesel. Mirrlees Watson was based in Scotland Street and finally closed business there in 1966. This seems to have been part of the general decline in engineering in Glasgow, even of long established and successful companies.

James (Paraffin) Young

Inventor and First Oil Tycoon

For those of you who are interested in Scottish industrial history and life, you would get a pleasant surprise on visiting Australia. In that country you will find countless examples of the engineering products of Glasgow and Scotland. In Sydney Maritime Museum is the HMAS *Onslow*, a submarine built at Scott's on the Clyde, and the inside is bristling with labels from many Scottish engineering companies, including periscopes from Barr & Stroud, where I served my time.

There are public fountains and thousands of examples of cast-iron 'lacework' balconies produced by or based on designs from Walter McFarlane's Saracen Foundry.

In Queensland, in the rainforests near Daintree, I came across an ancient and abandoned complete sawmill whose centrepiece was a Lister engine complete with a large oil tank. On this tank was a label with a list of recommended oils, one of which was 'Scotch Oil'. We are very familiar with Scotch whisky, but this was a new one on me. While I was already planning for this book, and on the lookout for examples of Glasgow's industrial heritage, I was intrigued enough to investigate further.

While I was aware of the role of Paraffin Young in the development of the oil industry in Scotland, I had always thought that he was from Fife. It turns out that he was from the Drygate in Glasgow and had originally been apprenticed as a joiner to his father, John. His mother was Jean Wilson, who married John in 1809. Some say that he was also an undertaker. This may well have been the case, as very often those who made the coffins also helped bury the dead.

Like many ambitious men of the time in Glasgow, James attended night classes at Anderson's University (The Andersonian). Here, he

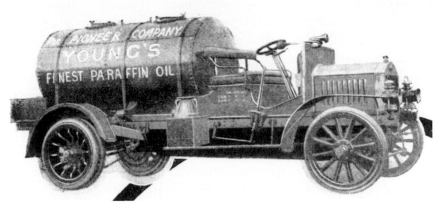

A Young's Paraffin Oil tanker on an Albion chassis from Scotstoun

was influenced by lecturer Thomas Graham. During his time here he started a lifelong friendship with David Livingstone and was to fund an unsuccessful search for him.

In 1831, Young was appointed as Graham's assistant and went with him when Graham moved to University College, London, helping him with his researches. In 1839, he moved as manager to Irishman James Muspratt's chemical works at Newton Le Willows, Merseyside, then on to Charles Tennant's works in Manchester. During this time, he investigated potato disease for the Manchester Literary and Philosophical Society, and suggested the use of dilute sulphuric acid in treating the tubers as a means of stopping the disease.

At the Anderstonian he had befriended Lyon Playfair, who wrote to him in 1847 telling him about a spring of oil in the Riddings Colliery in Derbyshire. This belonged to Playfair's brother-in-law. He though that Young might be able to turn it into a profitable venture. His employers apparently thought that it was not worth the bother.

So Young and Edward Meldrum bought the rights and started making oils for lights and lubrication. The spring began to fail, but during the three years up until 1851 he had been experimenting with the distillation of paraffin from coal and succeeded in this, with a patent in April 1851.

Another friend from his Anderson days was Hugh Bartholomew, who was by now manager of the Glasgow City and Suburban gasworks. He drew Young's attention to Boghead coal from Torbane Hill, near Bathgate. This coal is actually an oil-shale and this area had the world's

highest concentration. It was given the name 'Torbanite'. So began the exploitation of Scottish oil shale, with a works at Bathgate.

While people in other countries were working on similar principles, it was Young who started the successful commercial production of oil. A second works was to follow at Addiewell. Young's works employed 13,000 and overall there were around twenty separate extraction and processing companies with a total workforce approaching 45,000. At its peak, up to three million tons of coal and shale were extracted each year.

Through licensing, Young's system travelled the globe and thus gave rise to 'Scotch Oil'. The products derived from shale as well as Scotch oil included lamp oil, lighthouse oil, fertiliser, naptha and lubricants.

However, the end was in site as, in 1859, liquid petroleum was discovered in the United States and found to be much cheaper than Young's shale oil. Added to this, the Boghead coal reserves were coming to an end, as was Young's patent. His partnership came to an end in 1864.

While other forms of wax candles were around for a long time, obtaining the necessary ingredients was often costly, time-consuming and dangerous. You could almost say that while Young was inventing paraffin-wax candles he was inventing a whole new way to destroy the environment, but he was also helping to save the whale. For one of the main purposes of hunting whales was for spermaceti oil, which, when crystallised, produced cleaner and longer-burning lighting. It was also used for lamps and lubrication. Paraffin Young's oil began to replace all of these, although the light bulb put the tin hat on candles for most purposes. It is said that when he died, he had with him at his bedside the stump of the very first candle that he produced. We Glaswegians can be very sentimental.

But before we leave him, we should just mention that in 1872 he also discovered the use of quicklime to neutralise acidic bilge in ships. This significantly prevented rust in iron hulls.

He worked with Professor George Forbes to accurately measure the speed of light. Being a great friend to David Livingstone, he financed some of his expeditions as well as an unsuccessful search operation by Lieutenant Grandy when Livingston was missing. After Livingstone's death, he supported his family and contributed to the anti-slavery movement. He also paid for statues to be erected in George Square of his chums Thomas Graham and David Livingstone. While he paid for statues for others, it is strange that he has never been immortalised in bronze. However, he has a far bigger memorial. I said that as a by-product he

helped to save the whale. Again quite unconsciously, he has left us some stunning wildlife habitats in the bings composed of red blaes, which is what is left over after oil is extracted. Where these hills still exist, they have become habitats for a range of species. Forty species of bird have been recorded on one bing alone.

I said 'where they still exist'. This is because the red blaes has some value. It was used substantially in motorway construction, so a lot of them have been levelled. They were also used at one time as surface for football pitches and produced lots of skint knees.

James Young died in May 1833 and is buried at Inverkip. The James Young Halls at the University of Strathclyde bear his name, as does the James Young High School in Livingston. If you fancy a pint, there is also a pub in Bathgate with his name.